ANTI-STRESS COLORING BOOK

Day and Night

Journey into the Secrets of Nature

ILLUSTRATIONS BY SARA MUZIO

Sara Muzio

Sara Muzio has over ten years of experience working in graphic design and illustration. In 2002, after earning a degree in Medical Illustration, she began working for small graphic design studios and in 2004 she became the scientific illustrator for Lumen Edizioni, where she completed a postgraduate course on publishing and advertising graphics. From 2005 to 2011, she worked as a freelance graphic designer for private clients as well as public entities and publishing houses. From 2011 to 2013, she was the graphic and packaging designer for Sambonet Paderno Industrie S.p.A. She currently works as an illustrator and freelance graphic designer. In addition to the illustrations found in this book, she created those for *Flower Fantasy - An Anti-stress Colouring Book with 60 Illustrations*; *Hidden in the Jungle - An Anti-stress Colouring Book with 60 Illustrations*; *The Extraordinary Journey of a Little Goldfish - Anti-stress Colouring Book*; *Zen Gardens - An Anti-stress Colouring Book with 60 Illustrations*; *A Fantastic Journey along Swallow Migratory Routes - Anti-stress Colouring Book*; *An Incredible Voyage among the Stars - An Anti-stress Colouring Book with 60 Illustrations*; *Metamorphosis - Anti-stress Colouring Book*; *The Perfect Cat* for White Star Publishers.

WHITE STAR PUBLISHERS

WS White Star Publishers® is a registered trademark
property of White Star s.r.l.

© 2016 White Star s.r.l.
Piazzale Luigi Cadorna, 6
20123 Milan, Italy
www.whitestar.it

ISBN 978-88-544-1047-3
1 2 3 4 5 6 20 19 18 17 16

Printed in China

ANTI-STRESS COLORING BOOK

Day and Night

Journey into the Secrets of Nature

ILLUSTRATIONS BY SARA MUZIO

WHITE STAR PUBLISHERS

Introduction

The boundaries of our days, compressed as they are by the hectic rhythm of everyday life and punctuated by the lights and noises of cities that never sleep, have become blurred by now. A different reality, however, surrounds the creatures that inhabit the wild parts of the planet – where Mother Nature's rules still reign supreme and where sun and moon still follow one another in the sky, clearly separating the waking hours from those devoted to sleep.

In this elegant, original coloring book, you'll become involved, plate by plate, in the daily life of the most majestic, fascinating and curious animals, taking an imaginary trip around the world by their side. You'll see them playing with their young at dawn and protecting them in a warm, reassuring embrace after dusk. Night constantly succeeds day, thus creating two sharply contrasting worlds, translated by the artist into two parallel and equally captivating decorative styles. The plates that depict daytime are teeming with life, and feature a wealth of details and lots of light. The animals are portrayed in all their vitality, their unmistakable outlines surrounded by the natural environment they belong to. We find the same environment in the nighttime plates, equally elegant and detailed. Here, however, silence is everywhere, as we find ourselves immersed in the peace and tranquility of a sleeping world.

Now it's up to you: simply use colored pencils or markers to color the spaces outlined by motifs and lines, painting nature just as you like. And let yourself be captivated and seduced by this endless succession of light and darkness, vitality and quiet, noise and silence, day and night…

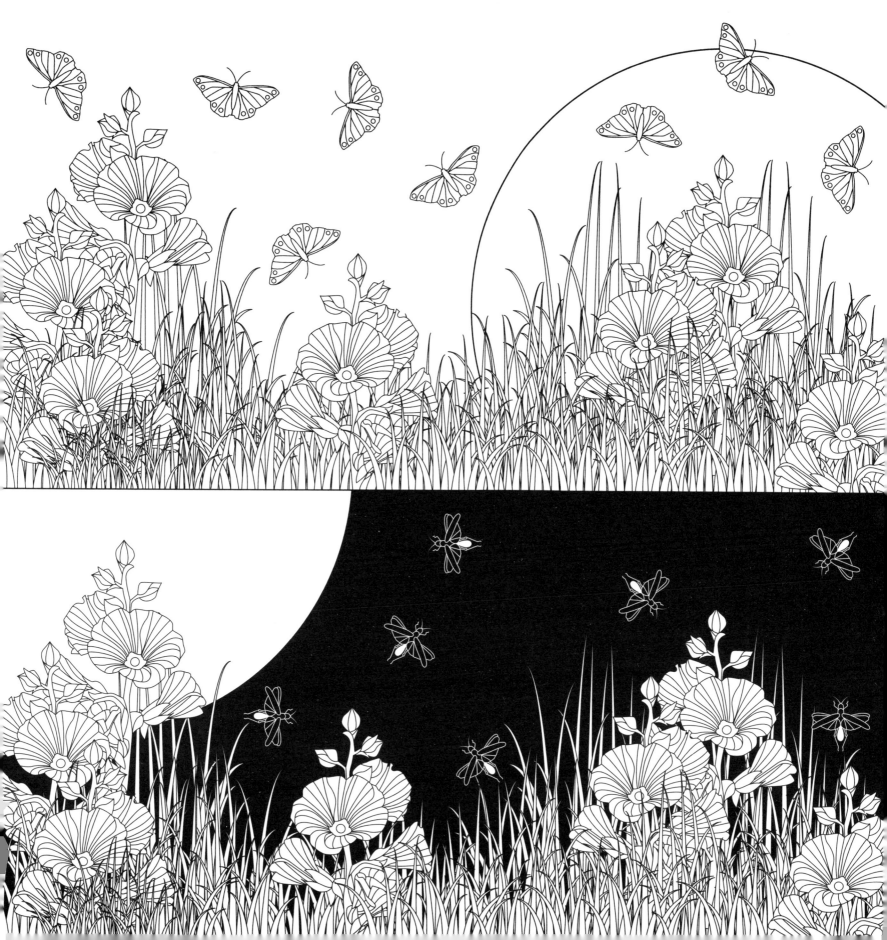

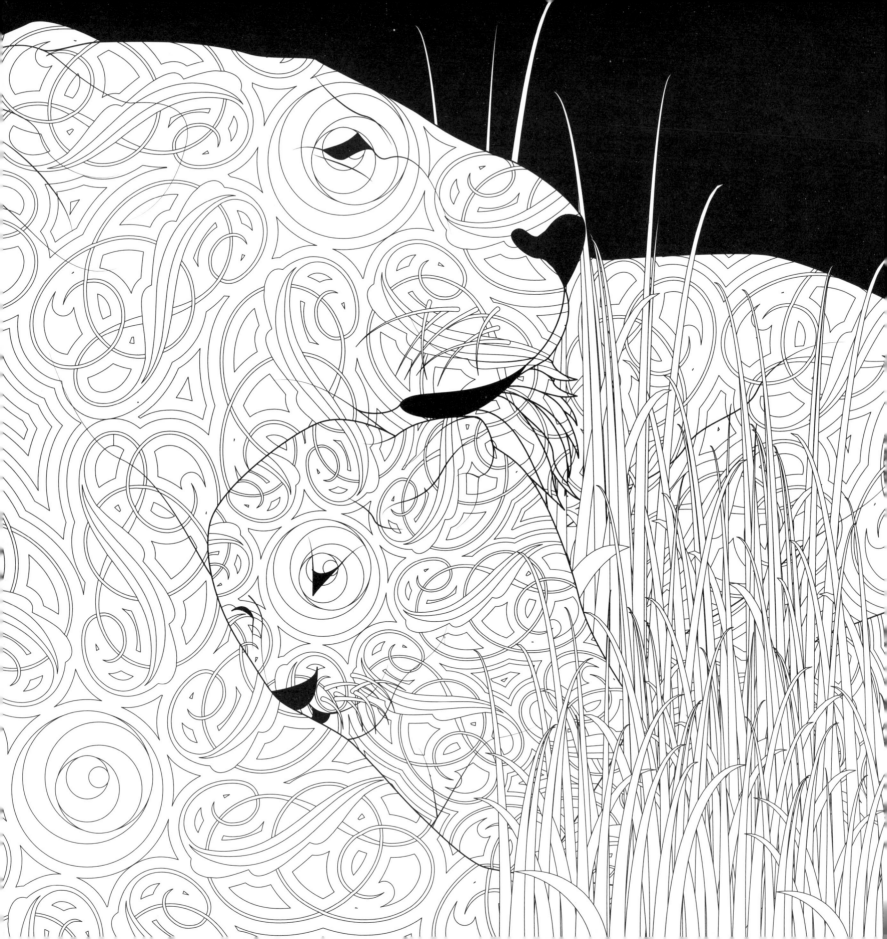

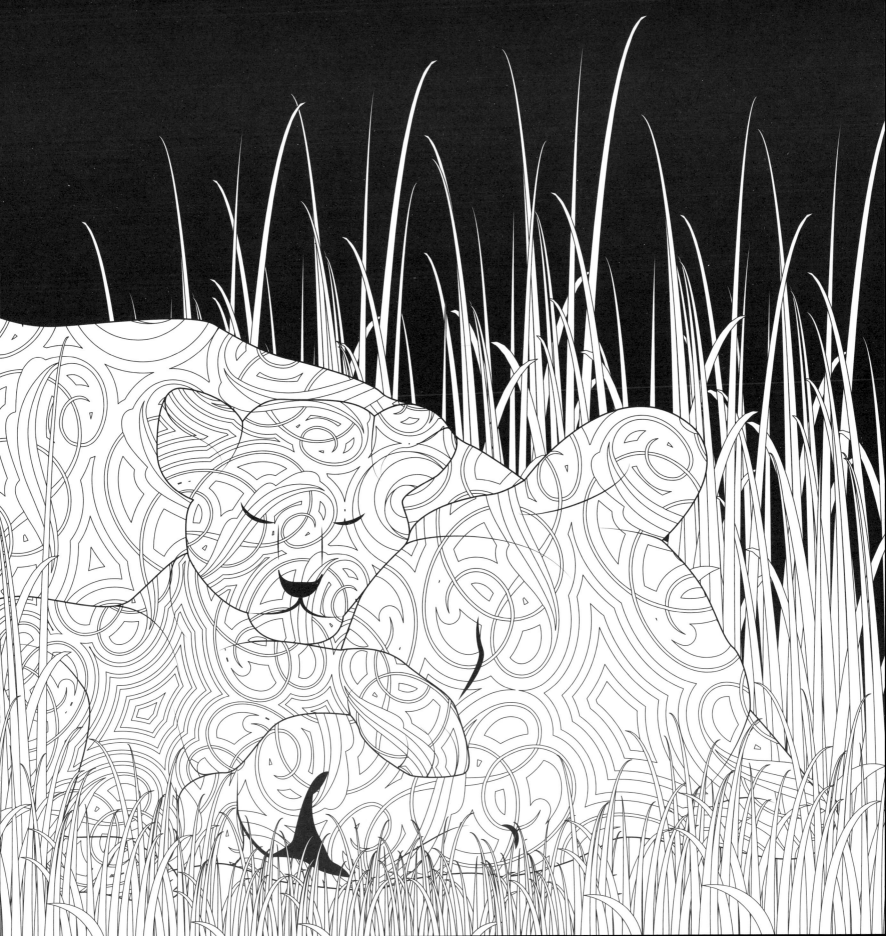

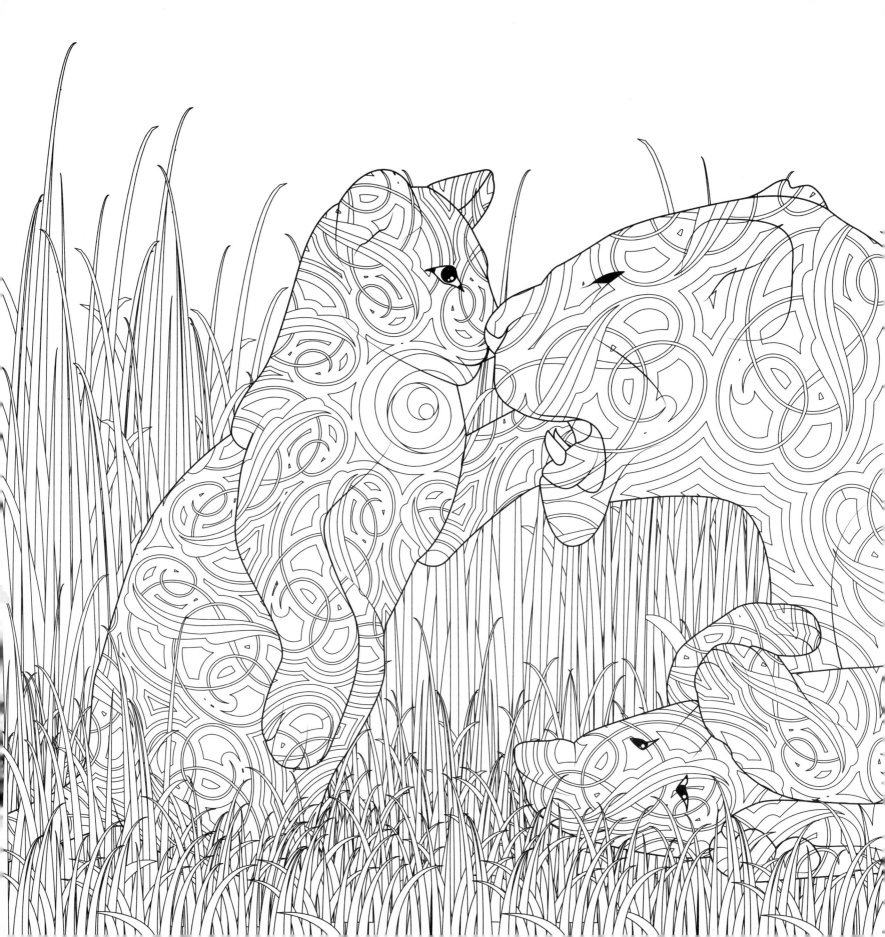

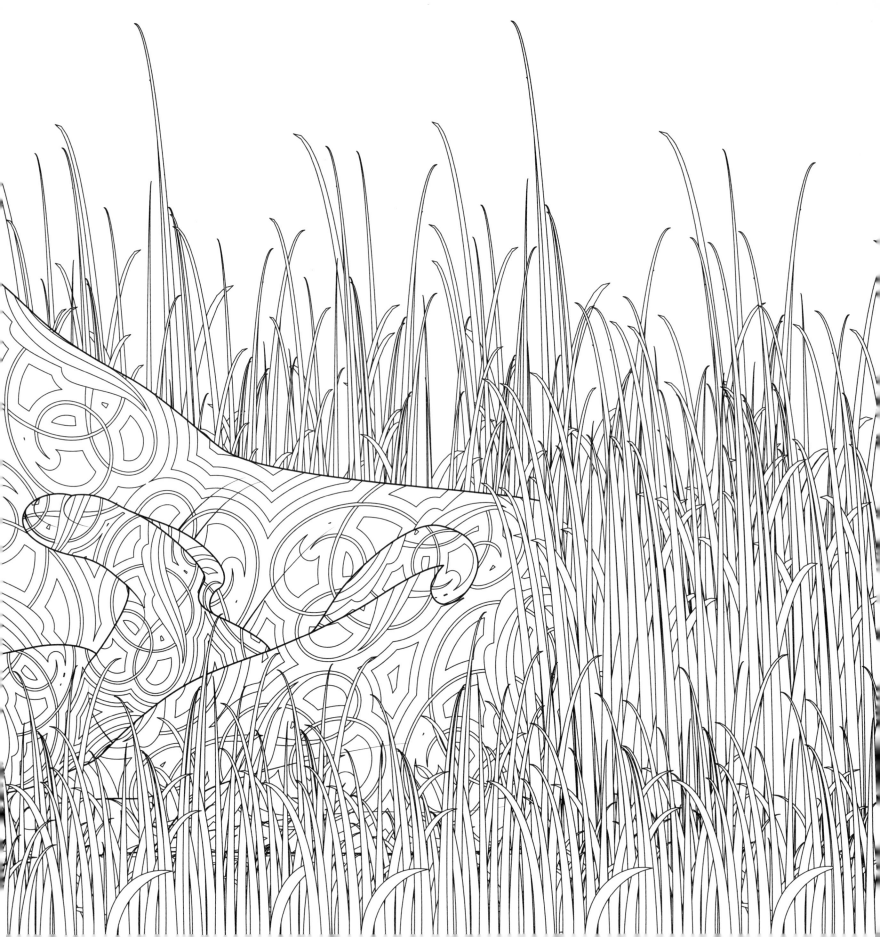

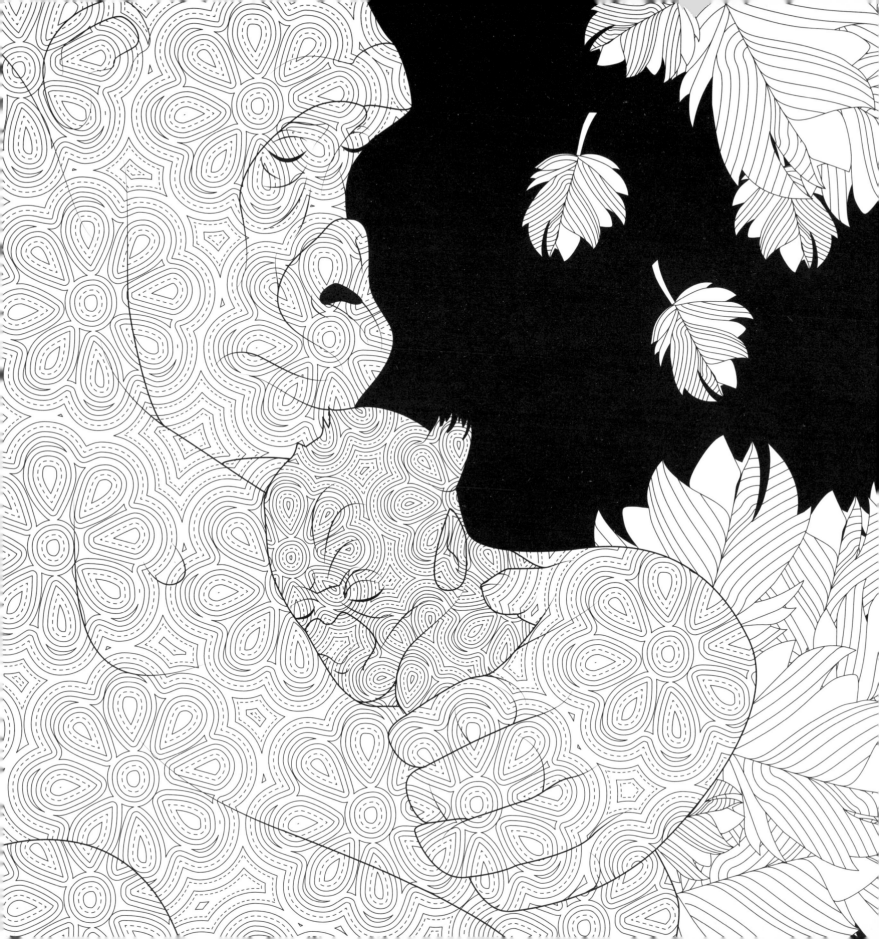

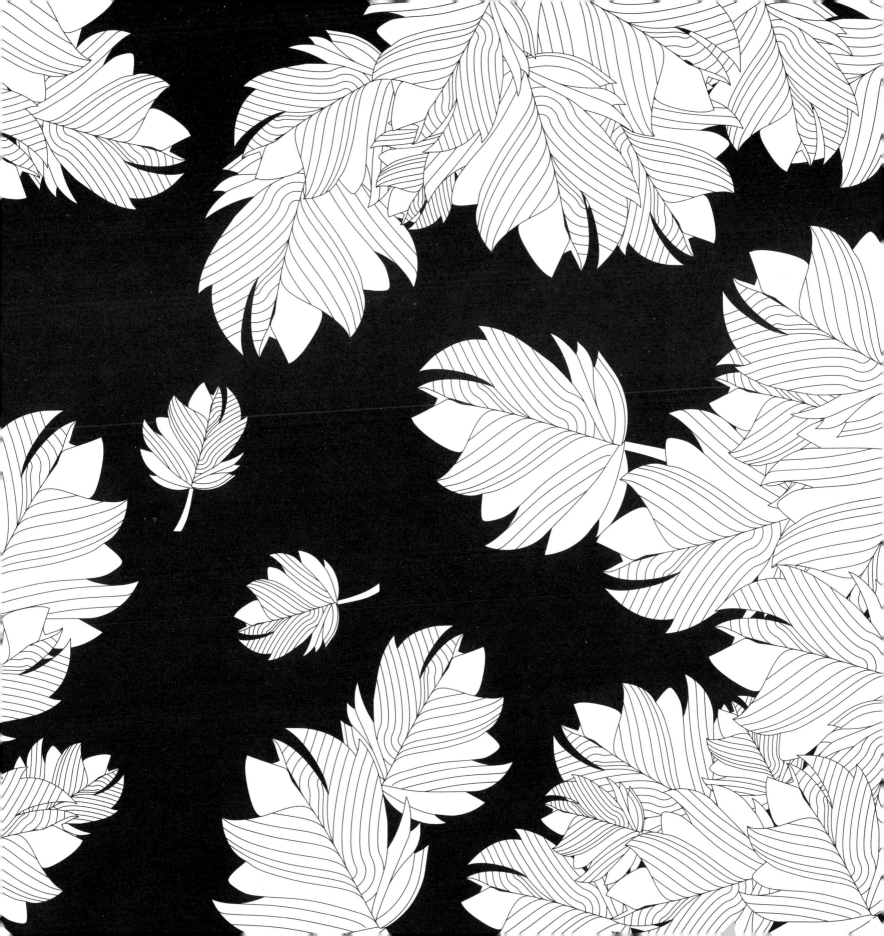

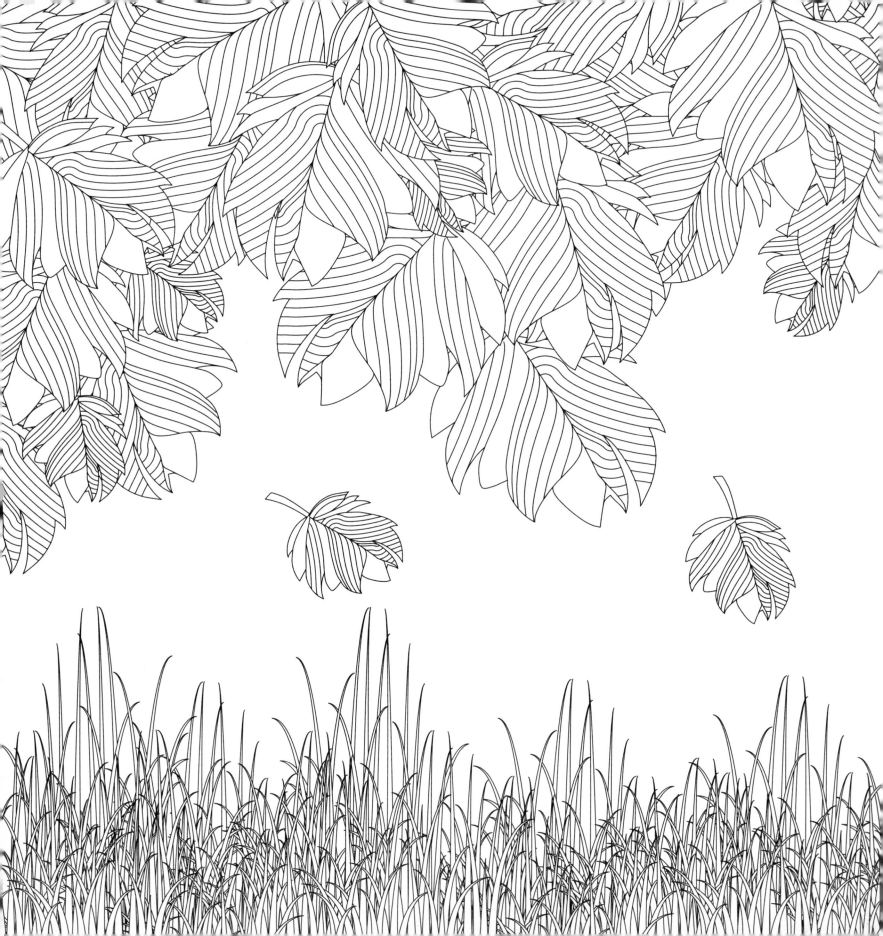

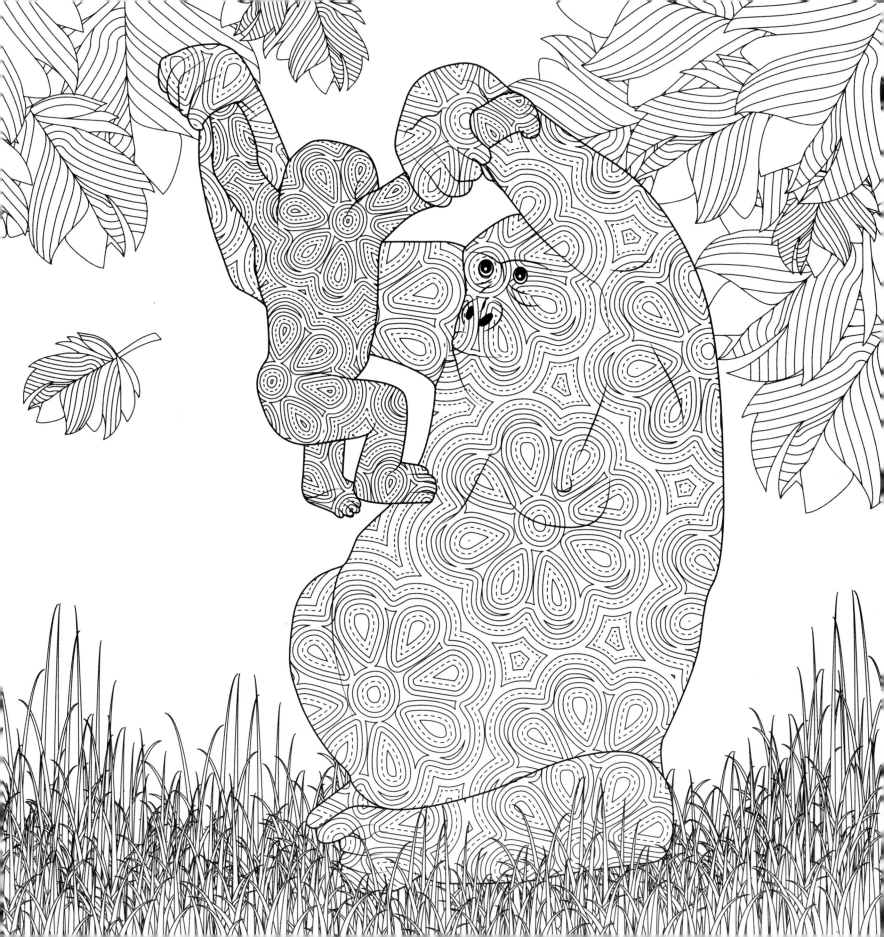

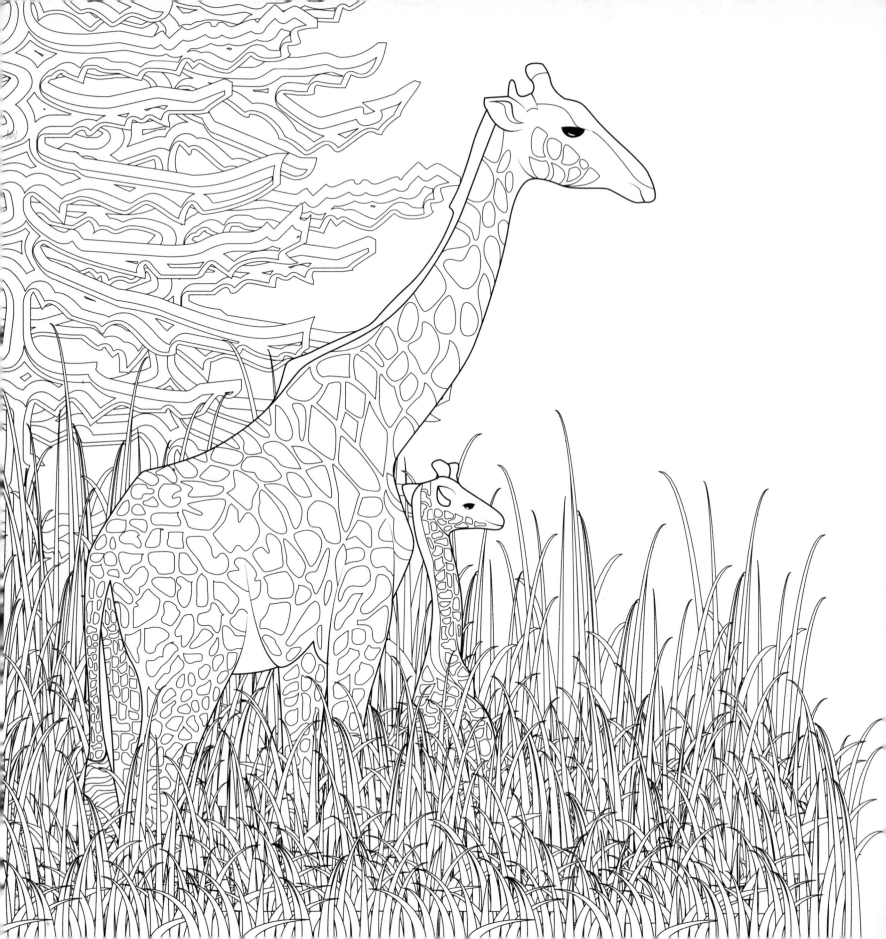

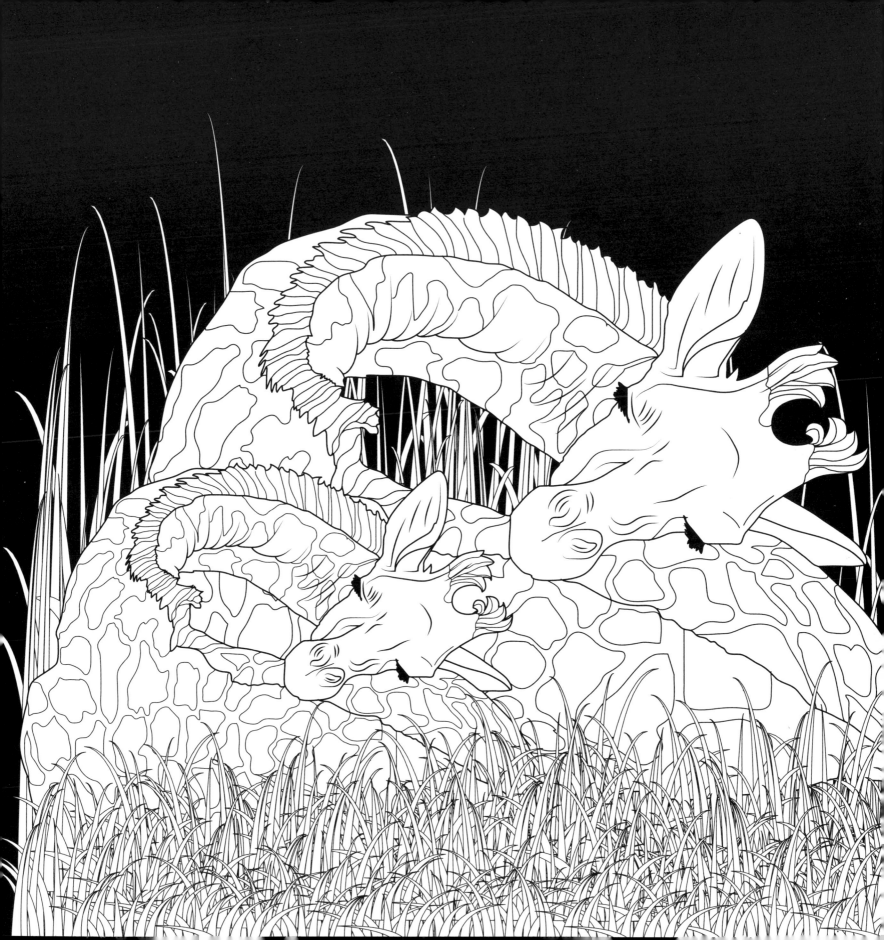

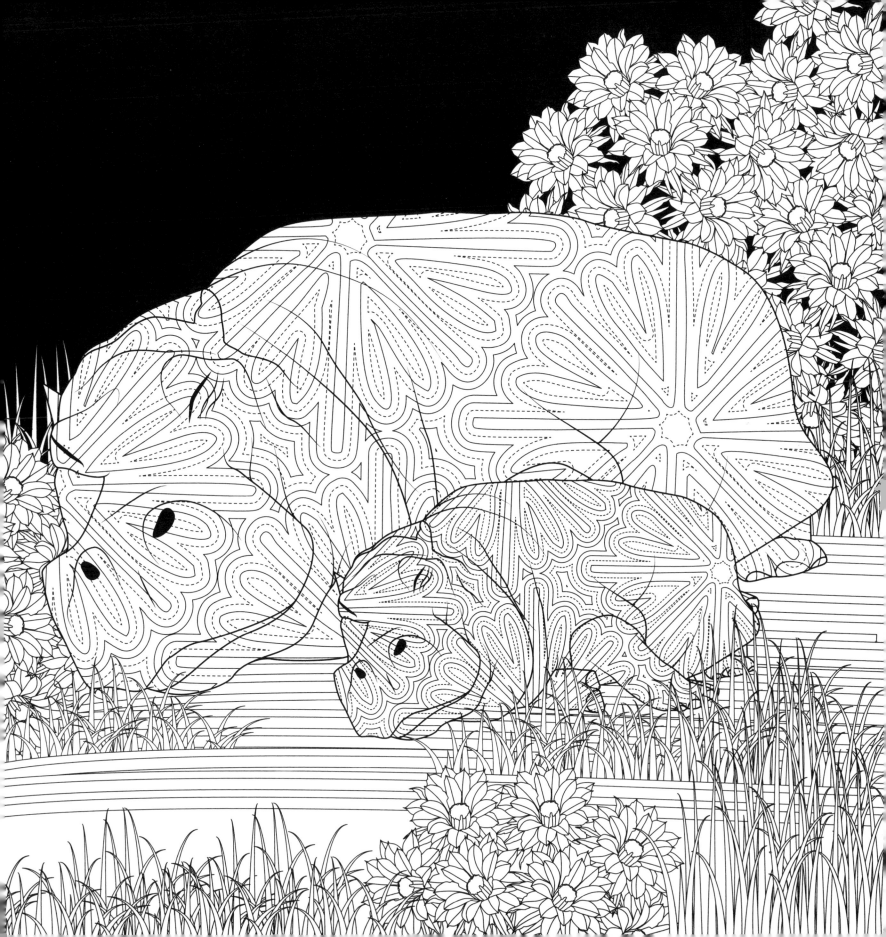

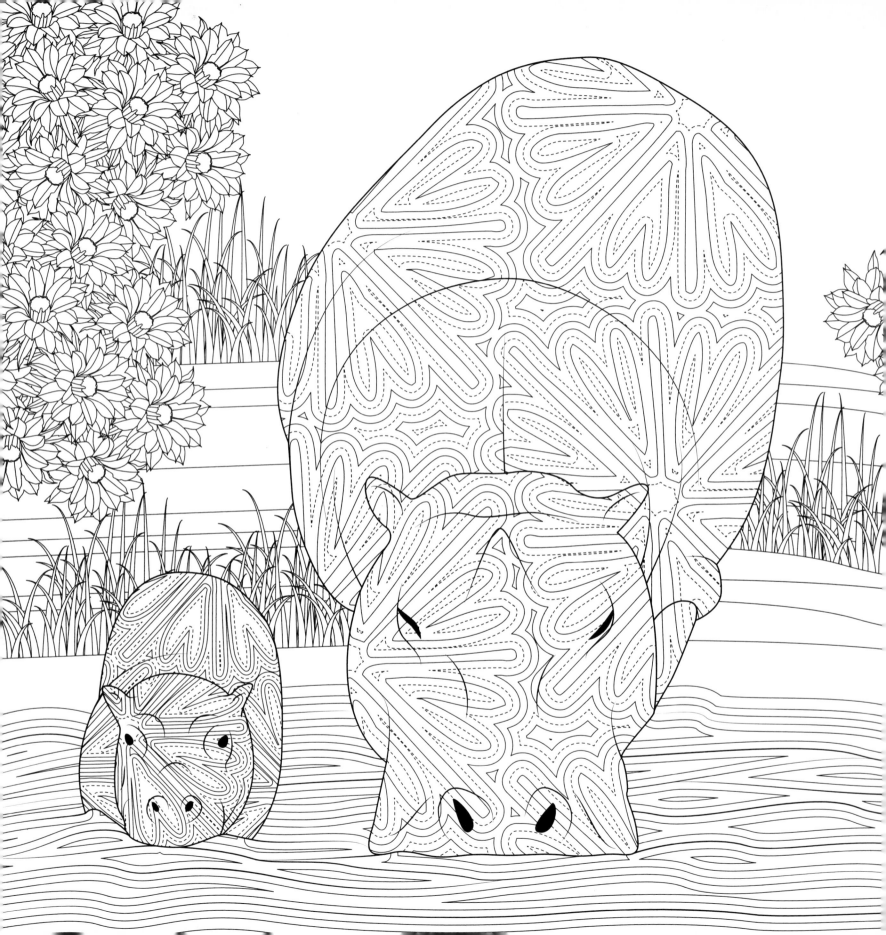

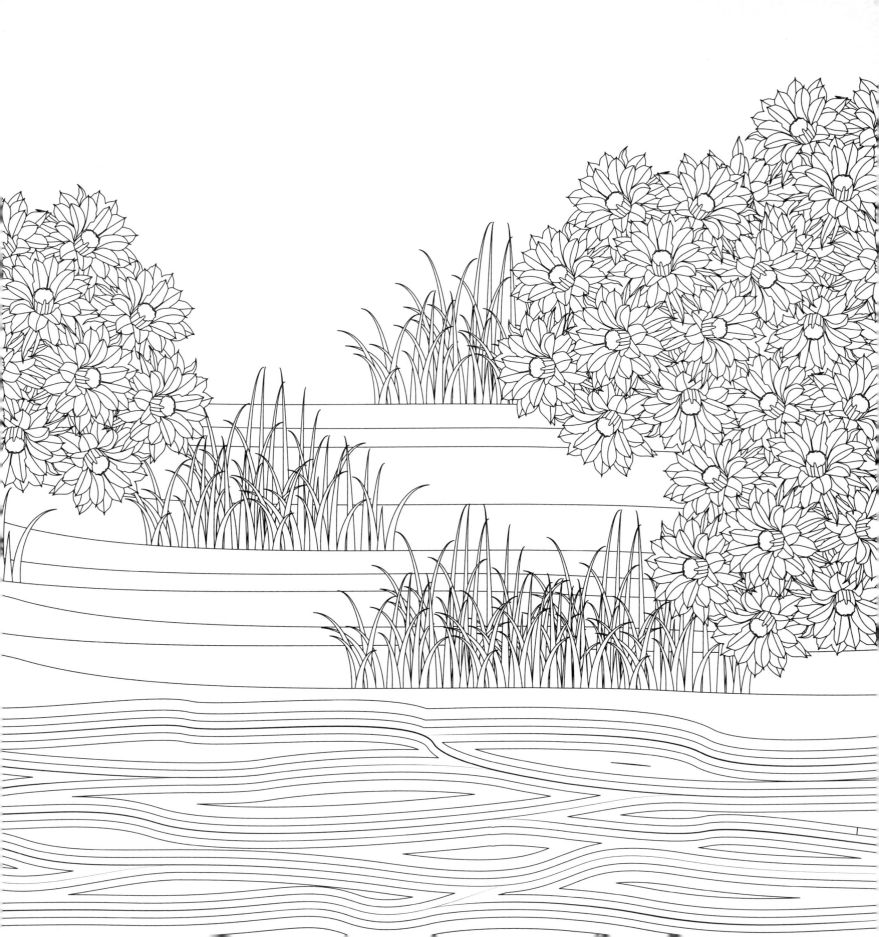

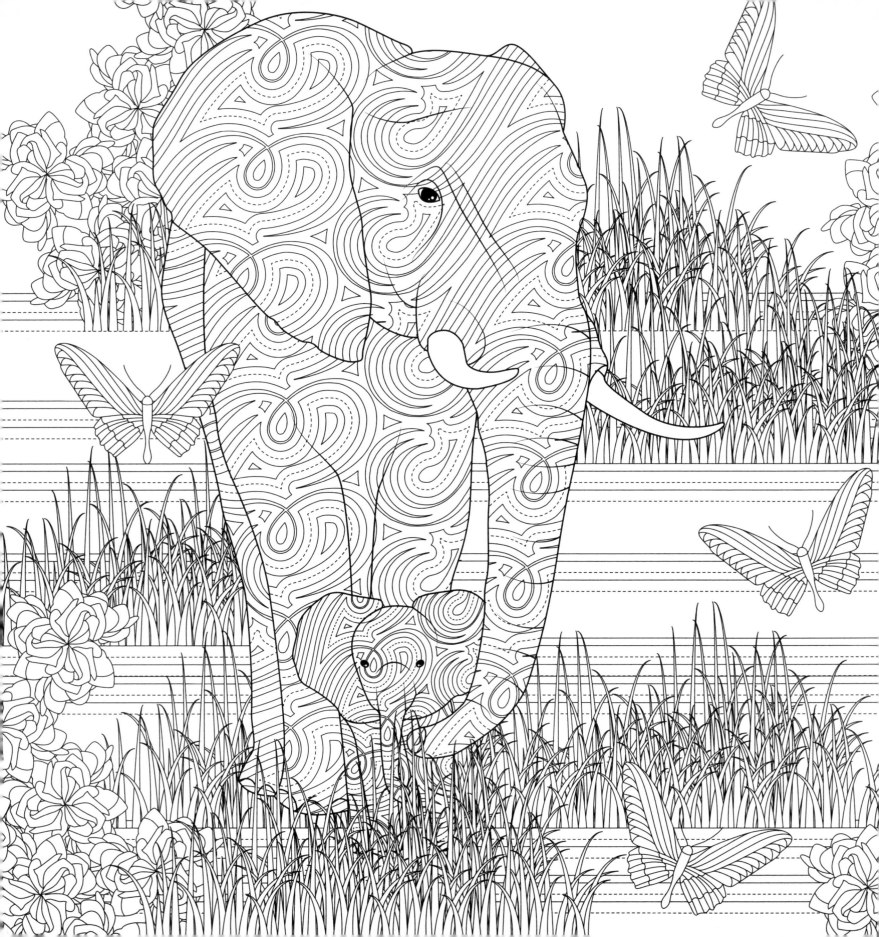

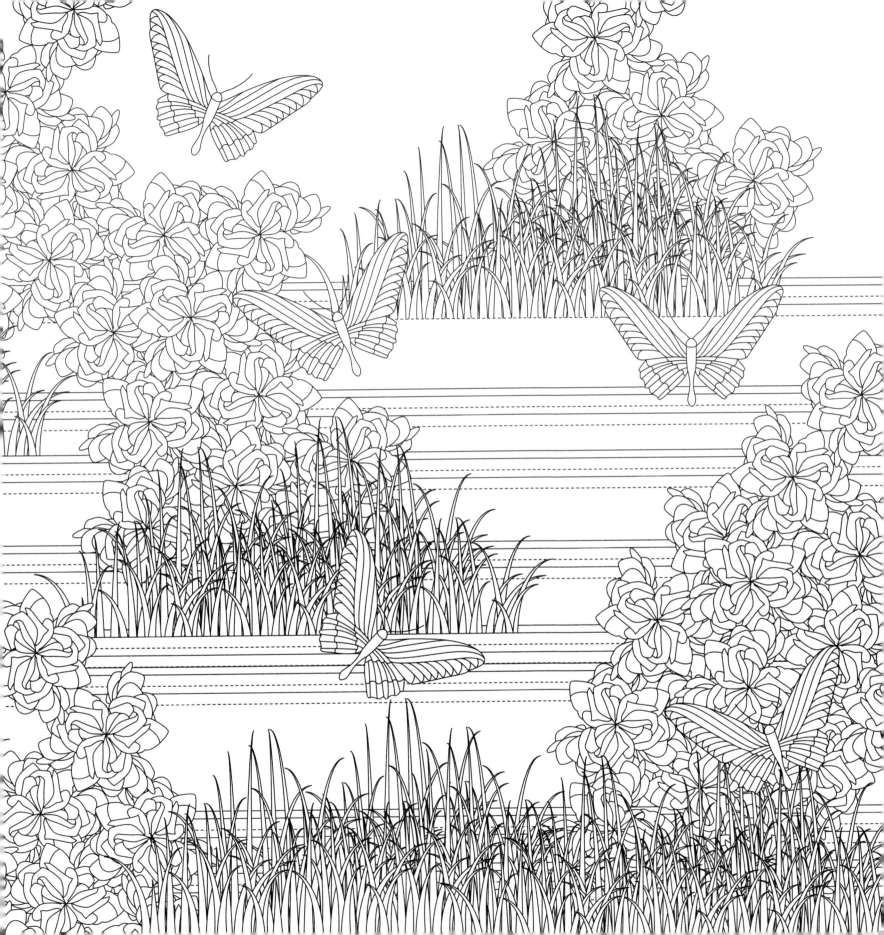

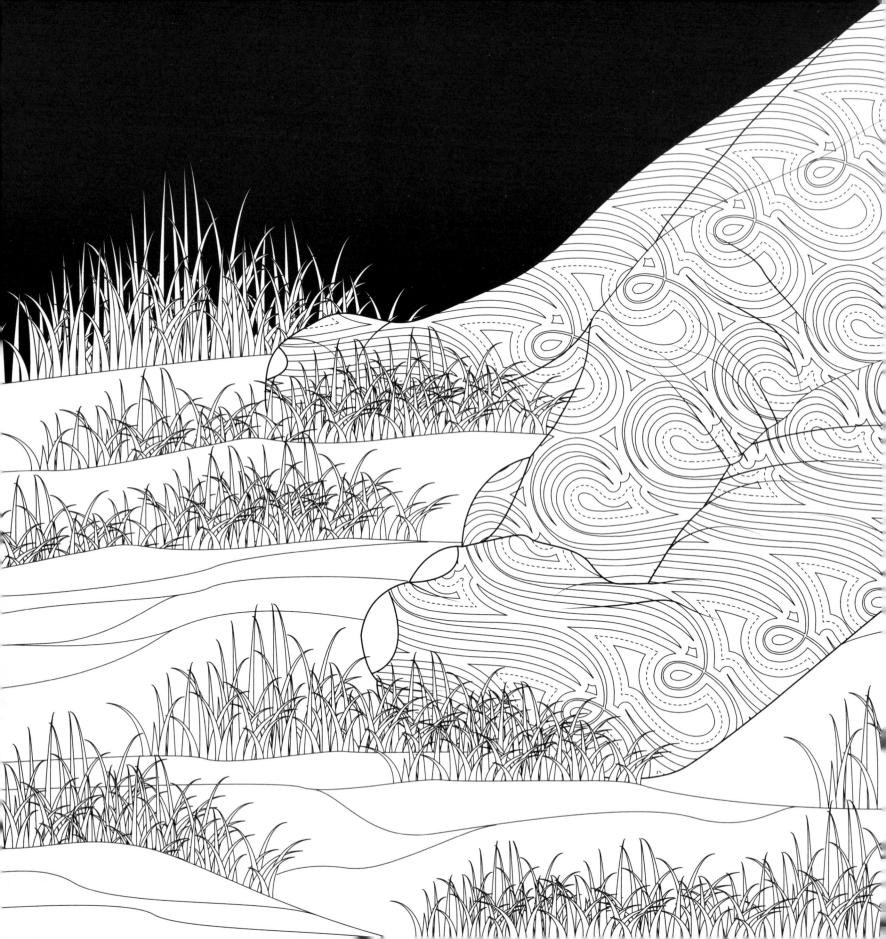

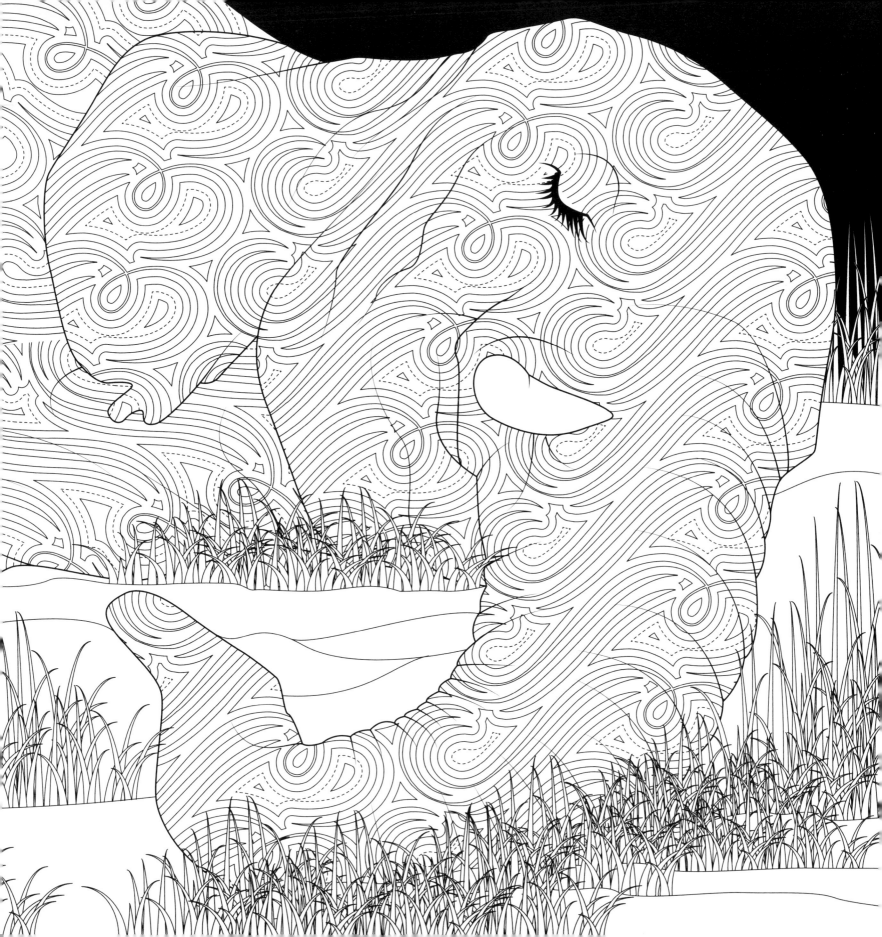

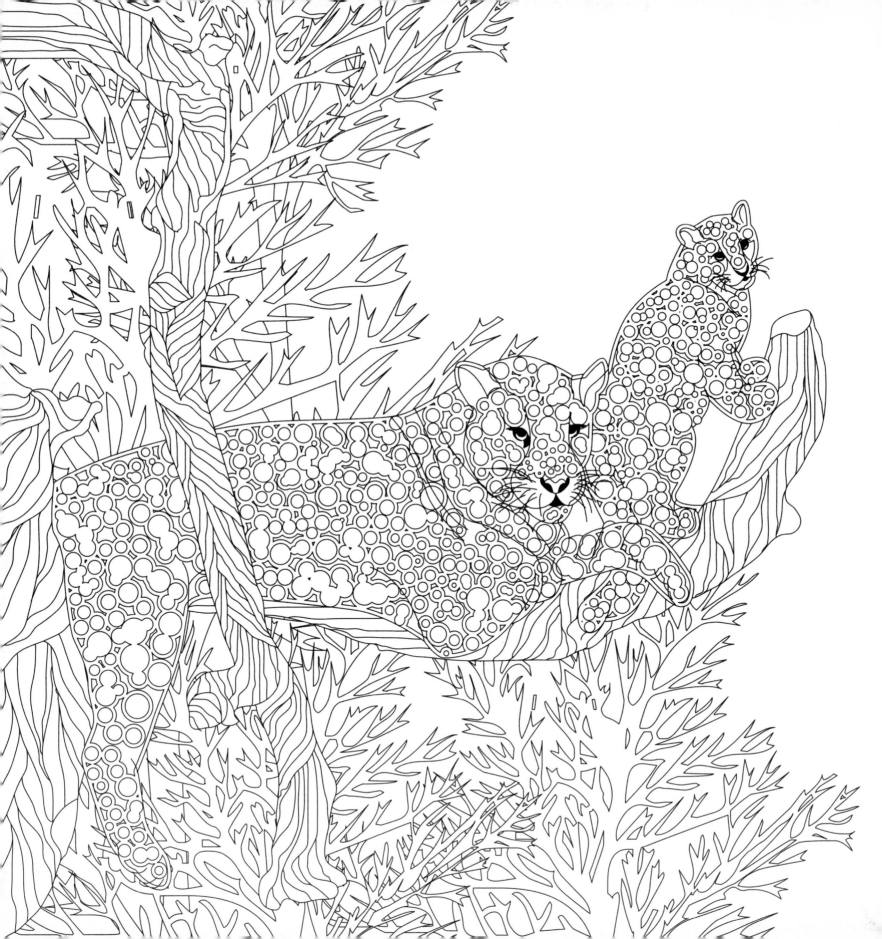

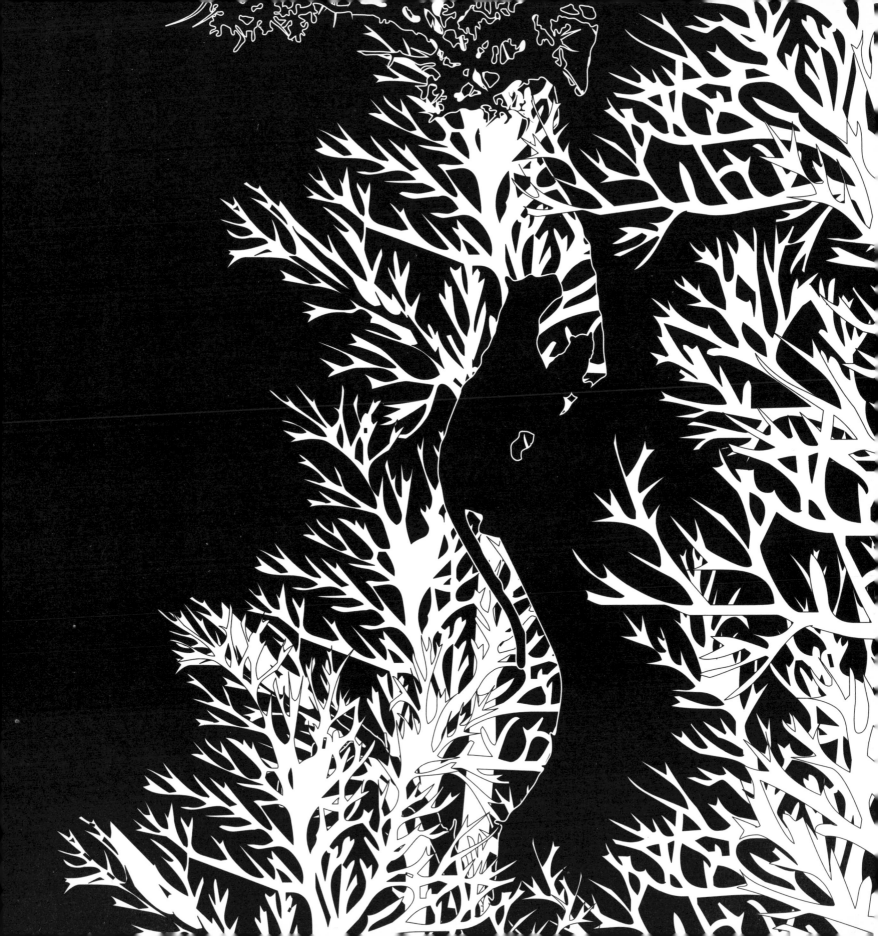

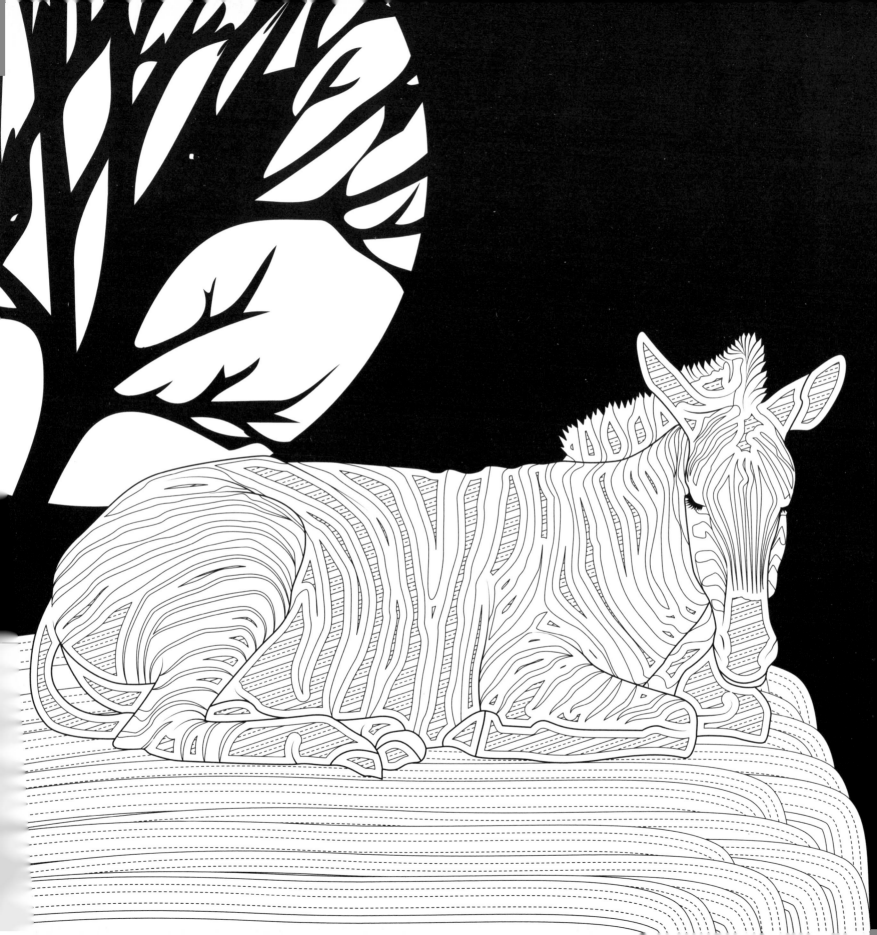

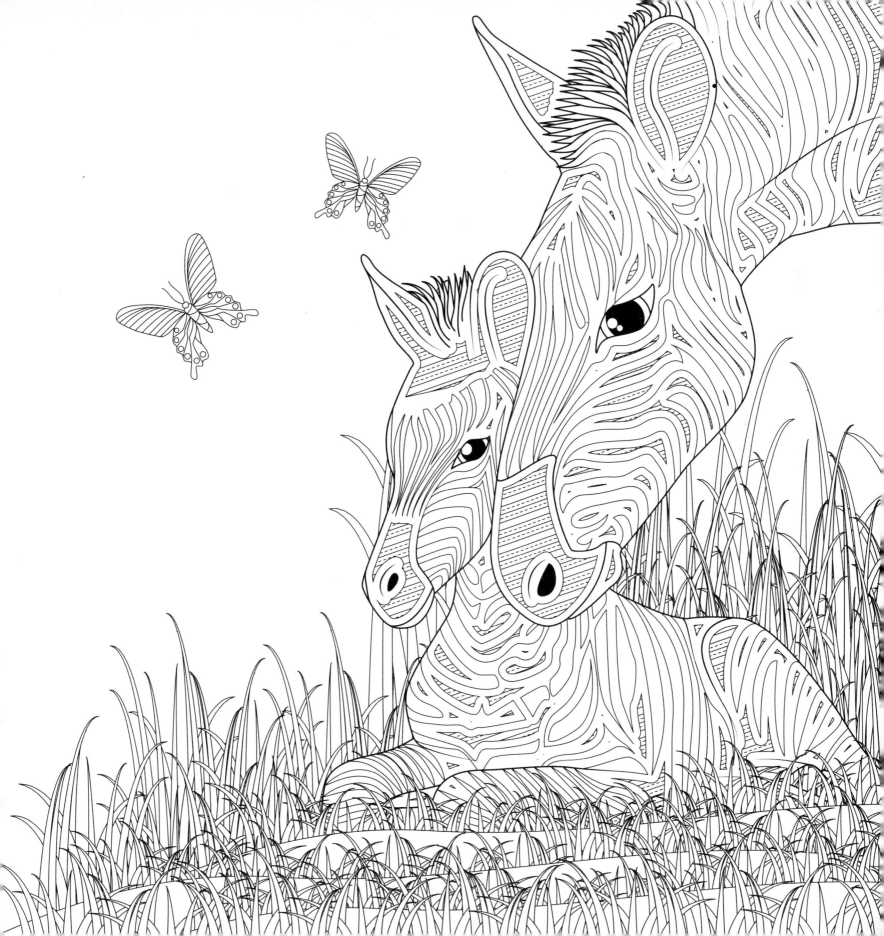

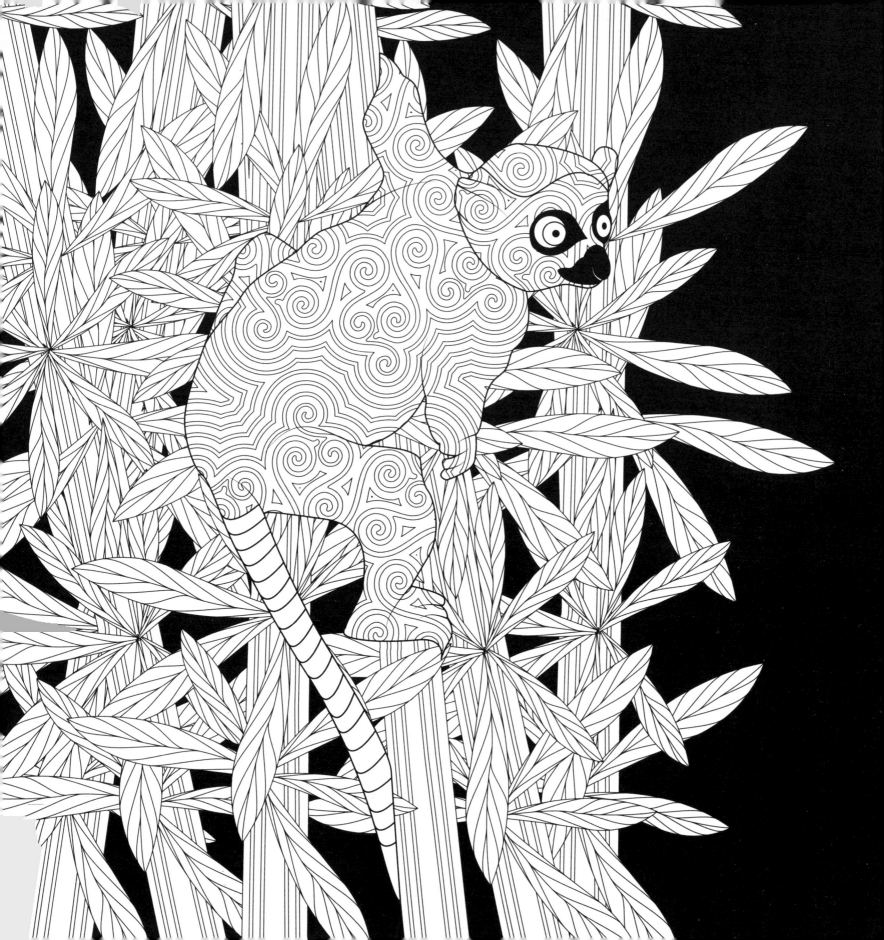

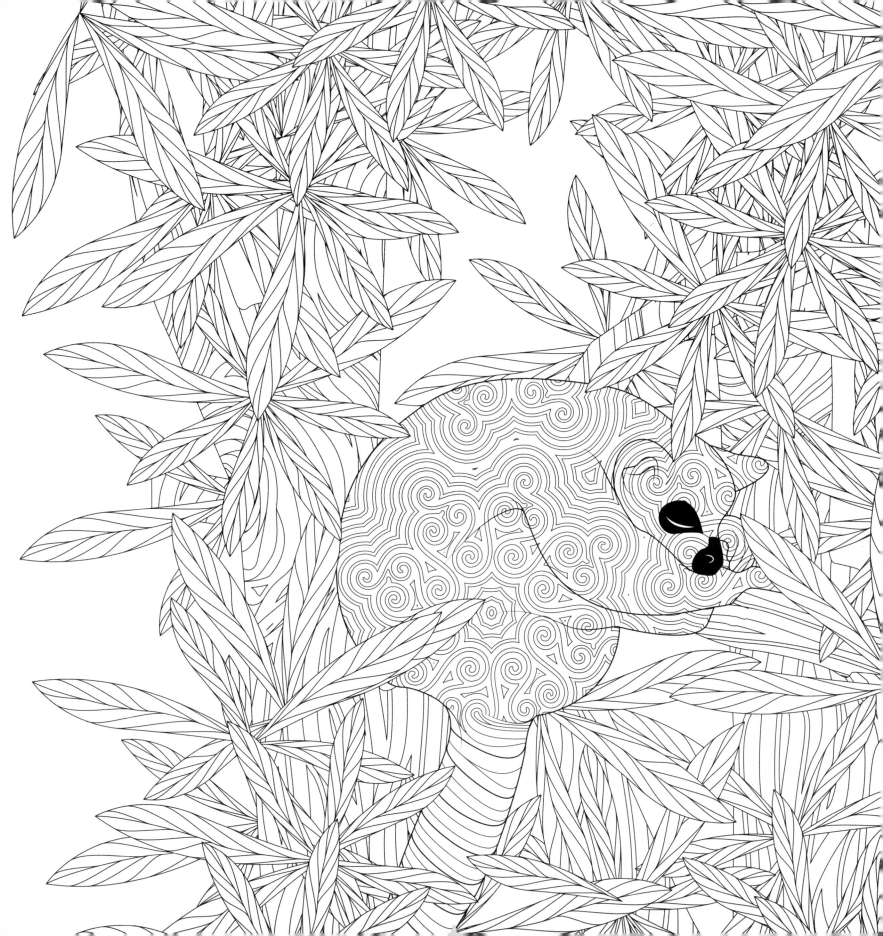

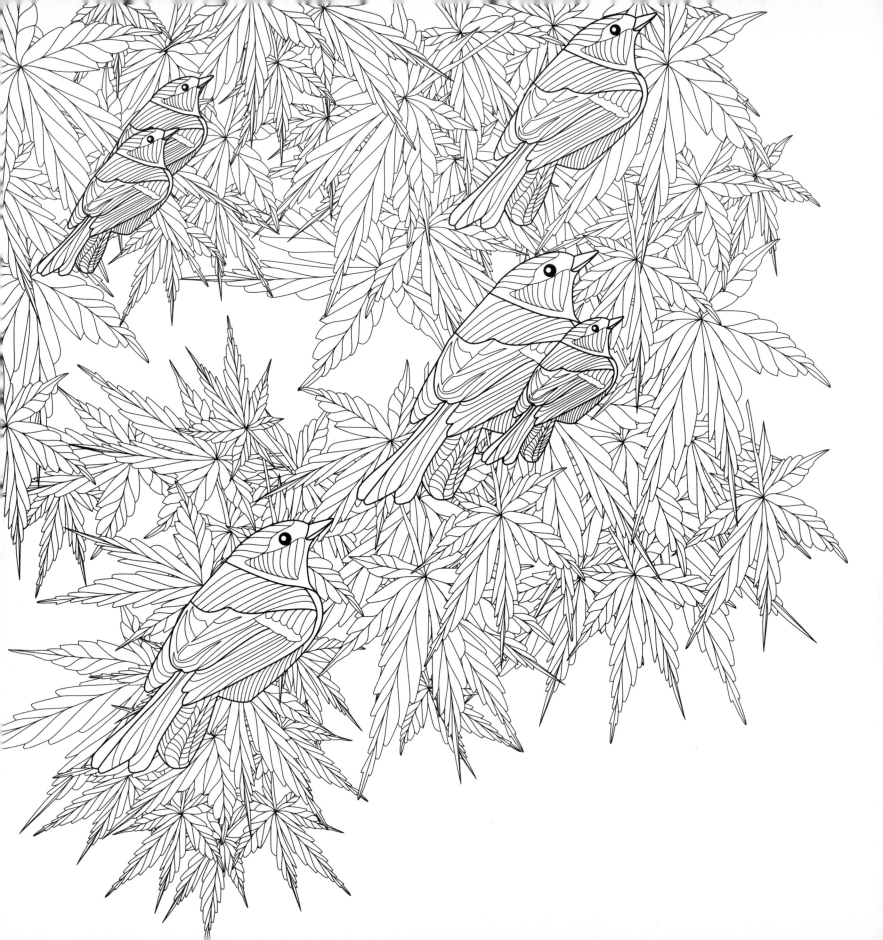

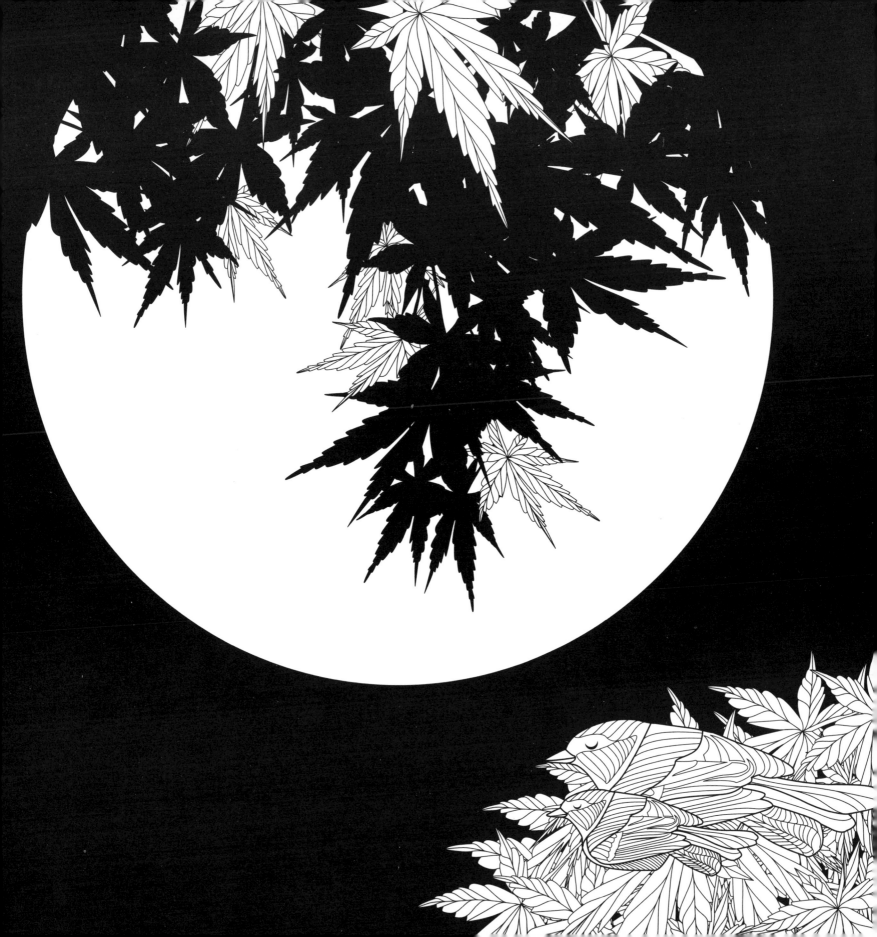

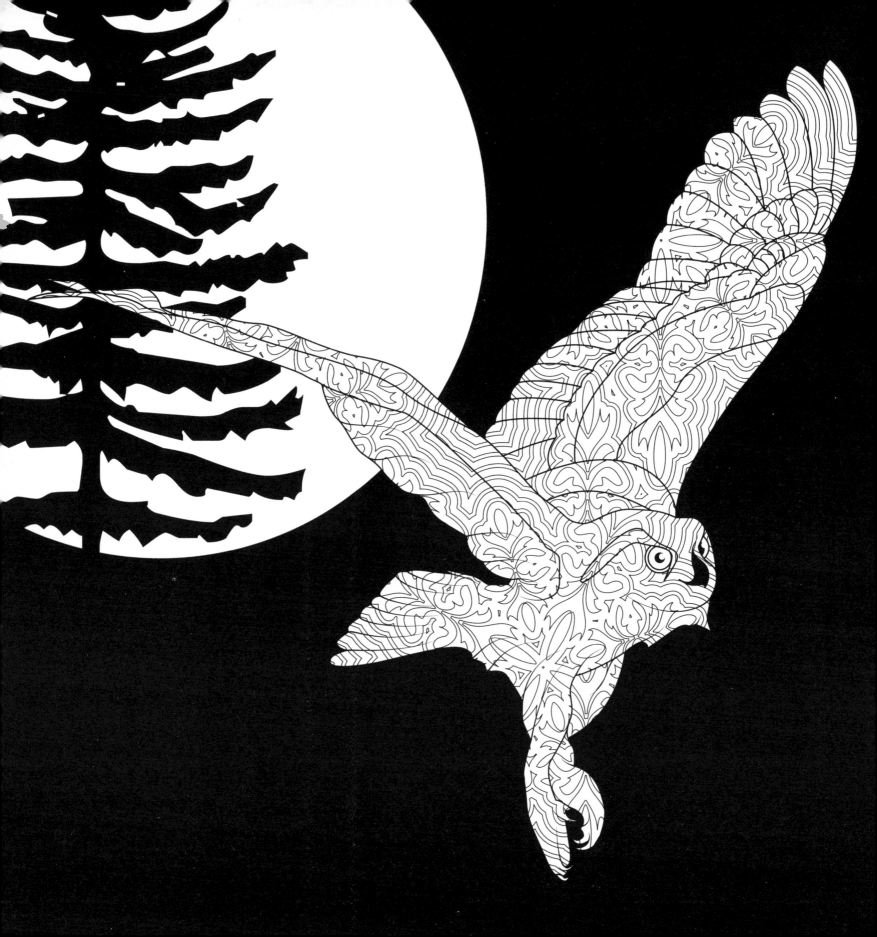

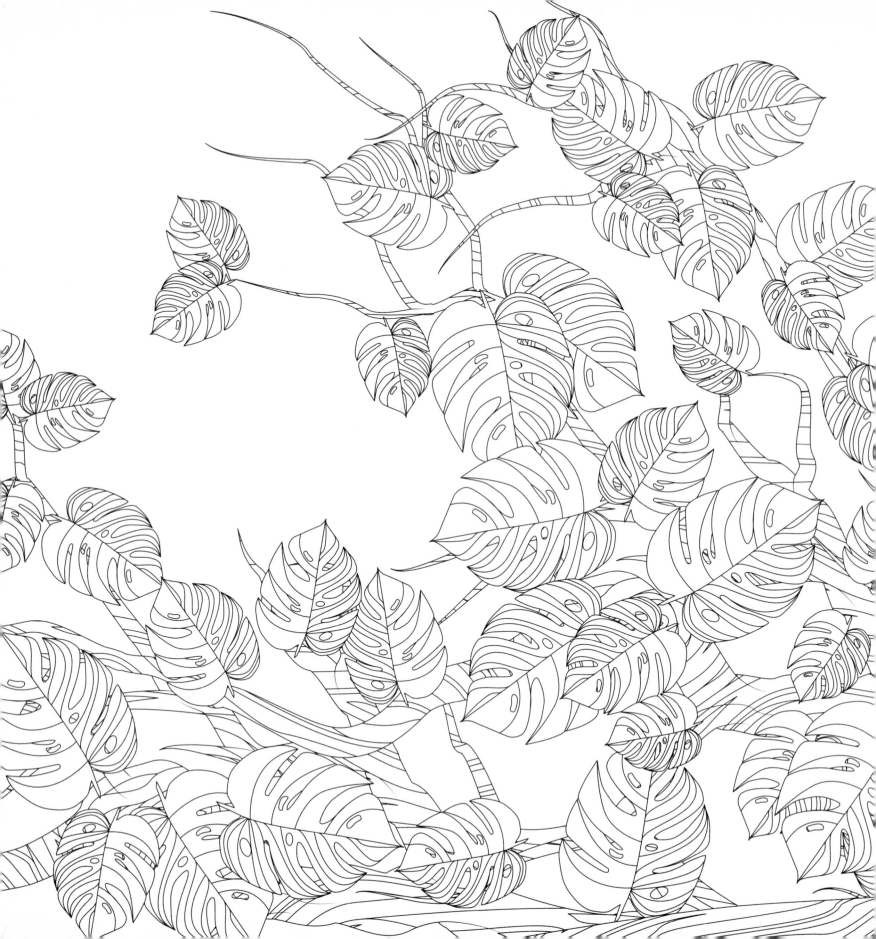

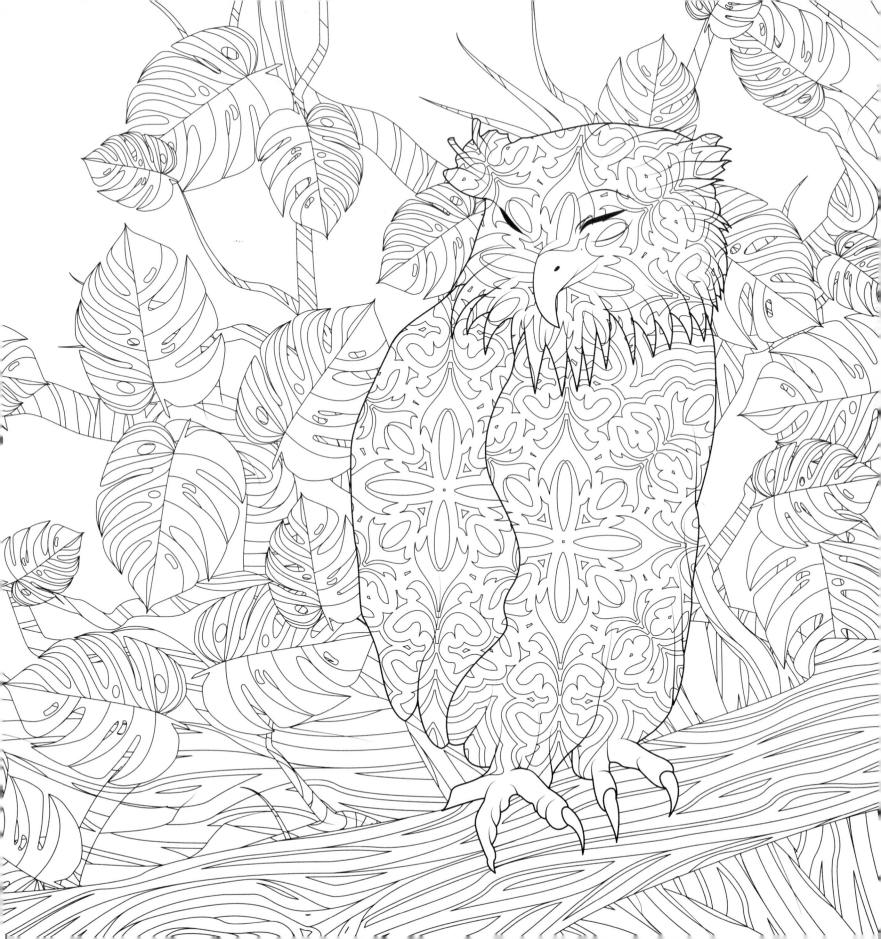

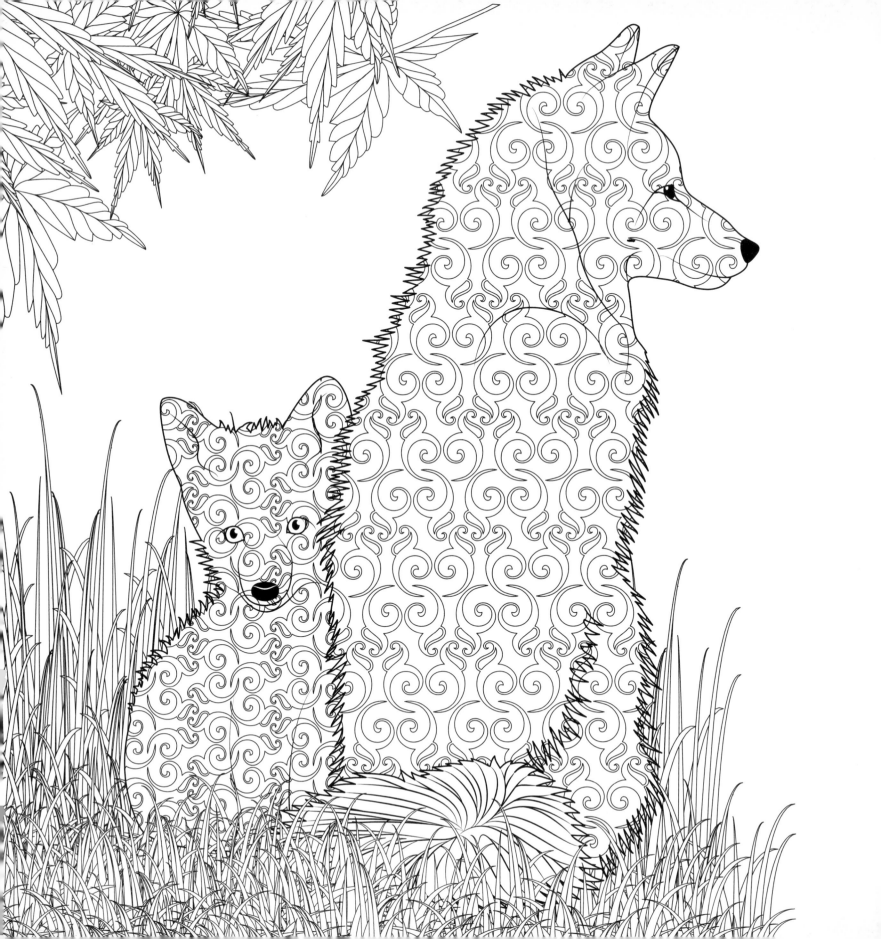

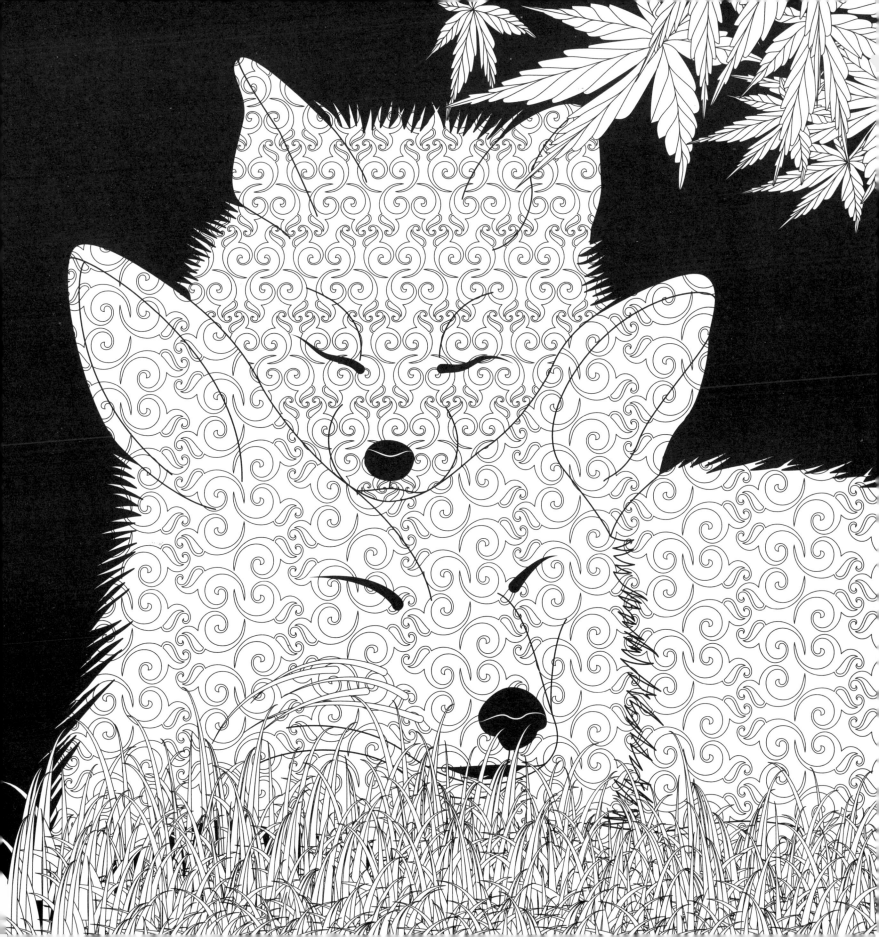

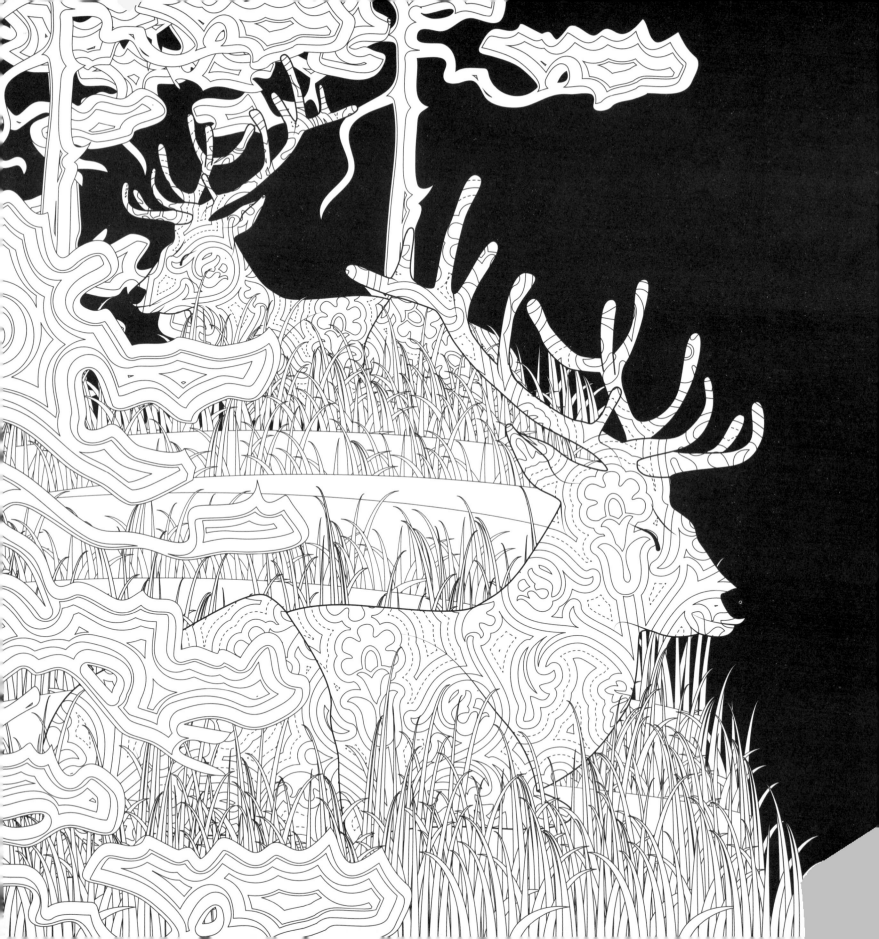

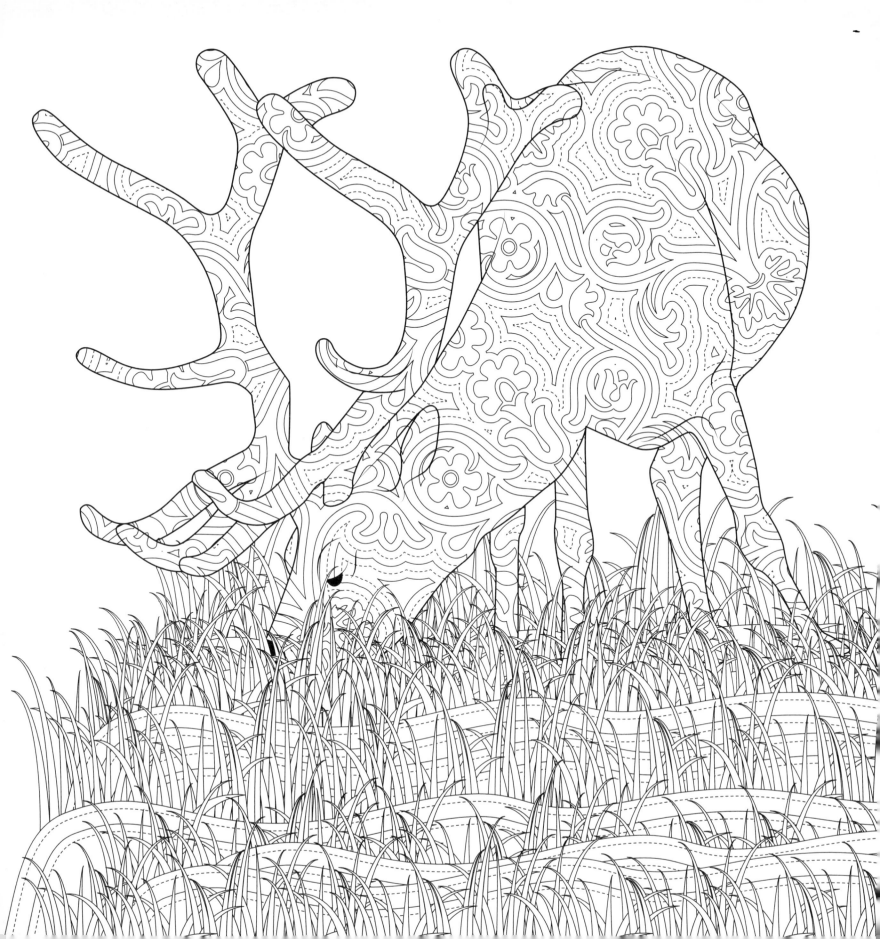

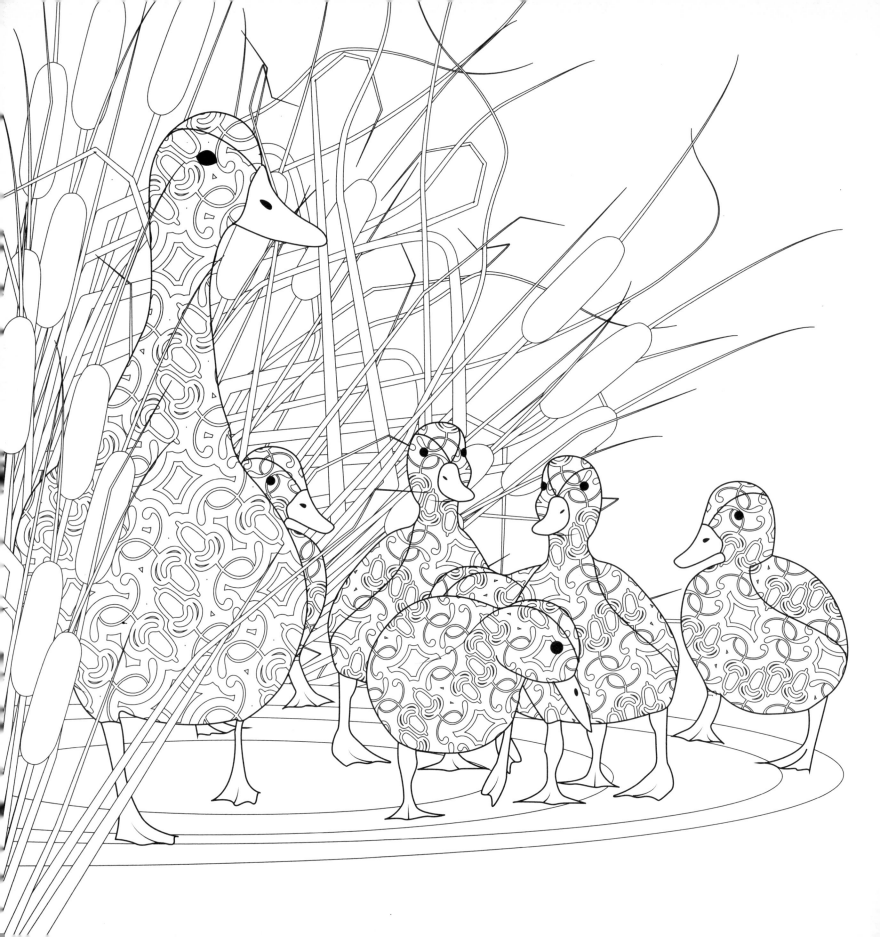

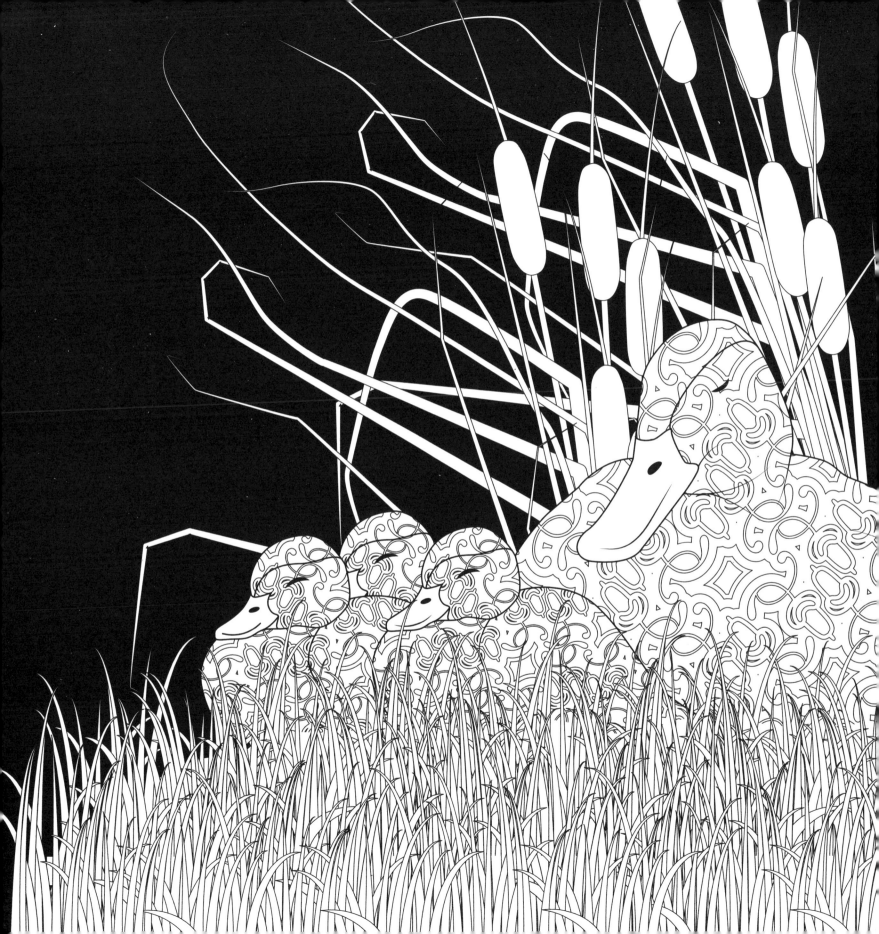

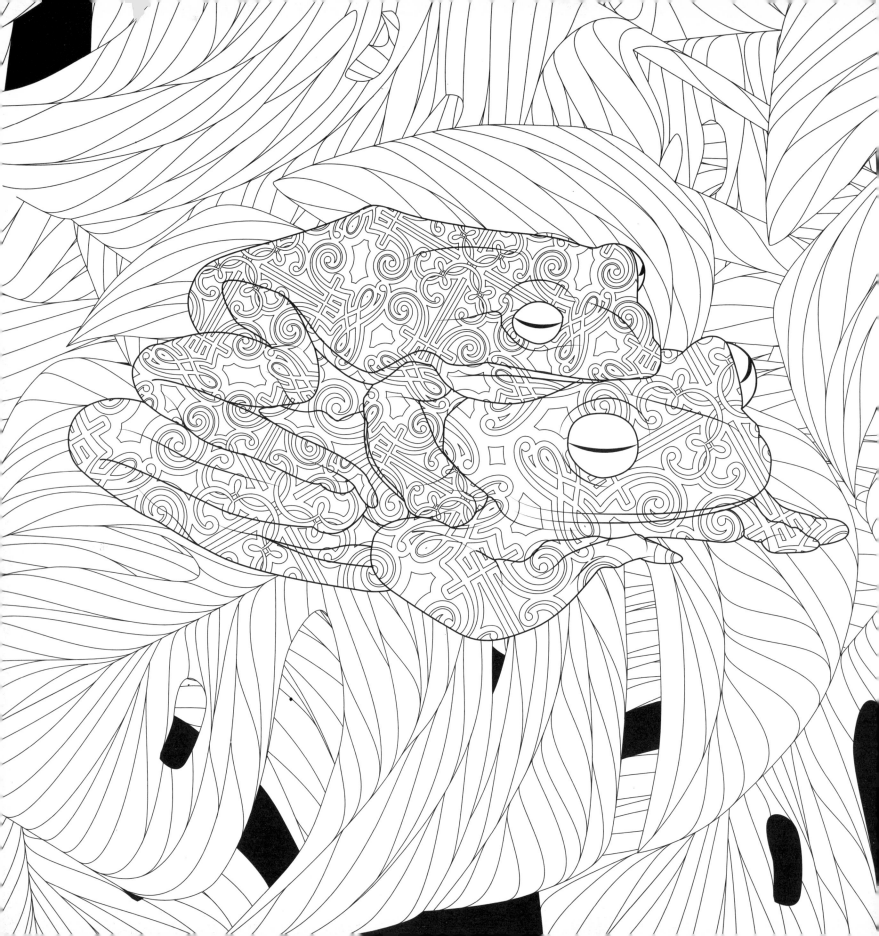

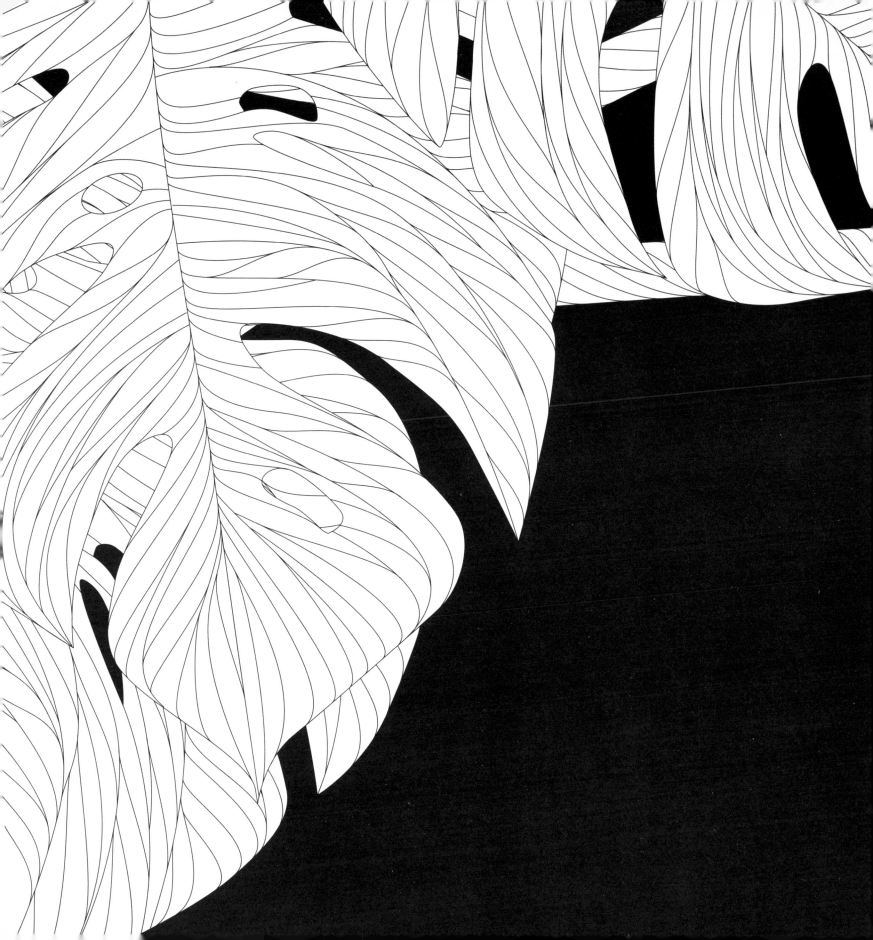

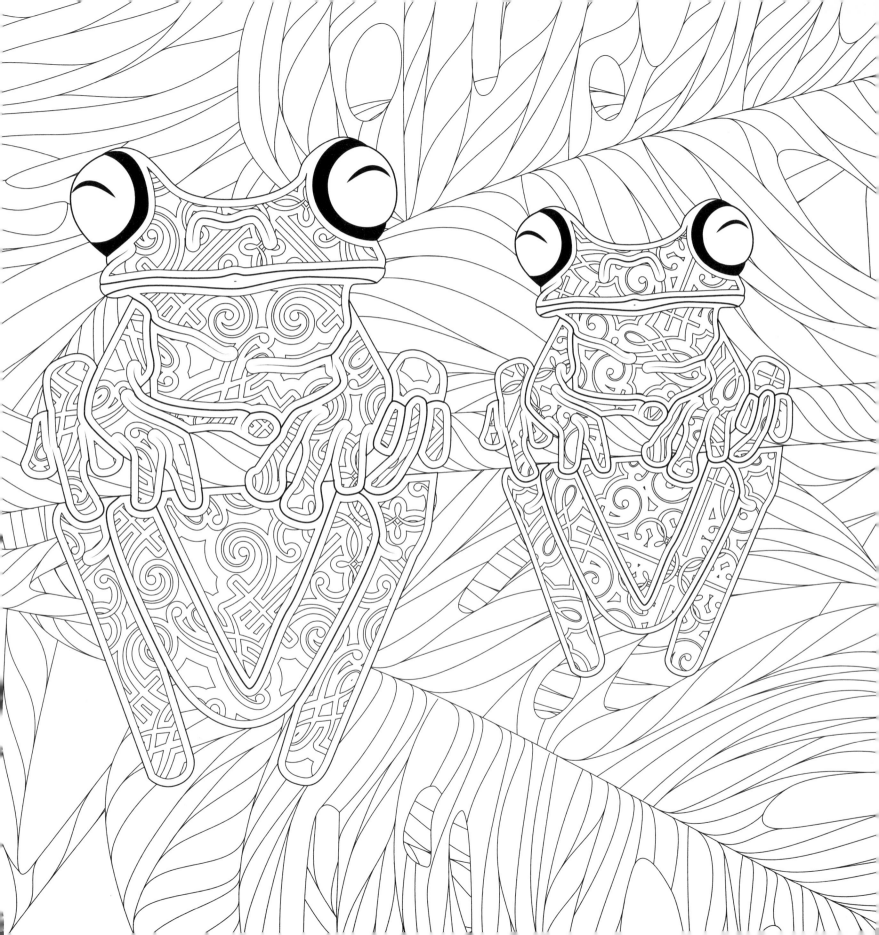

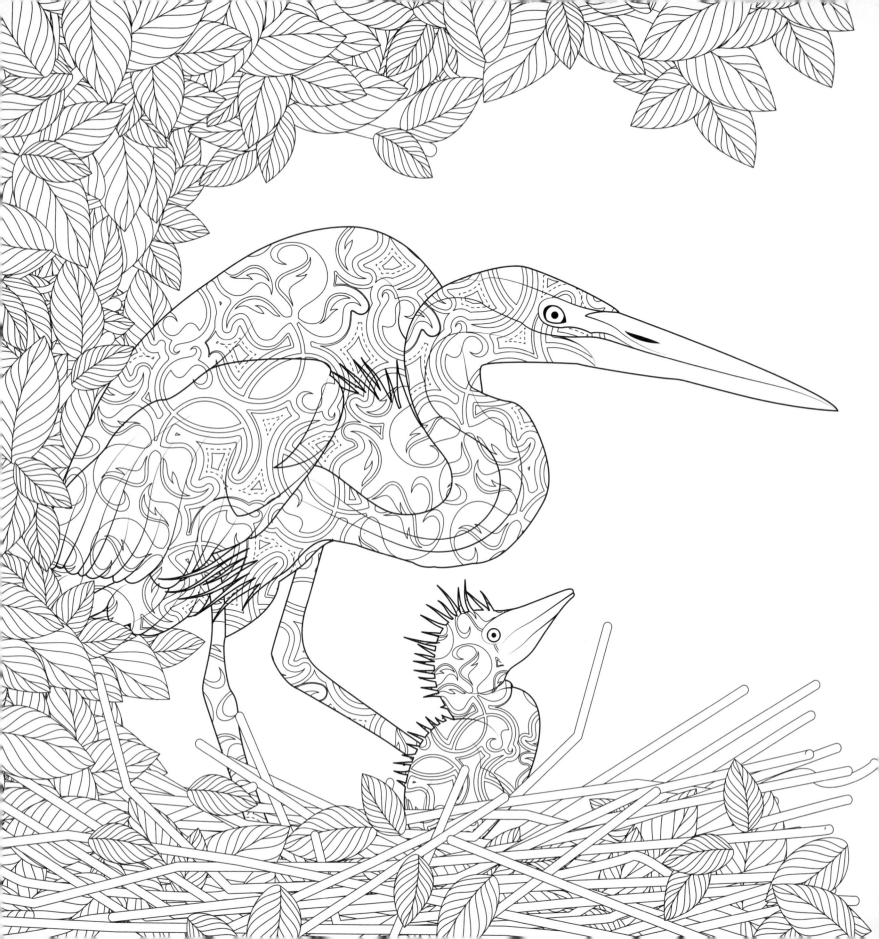

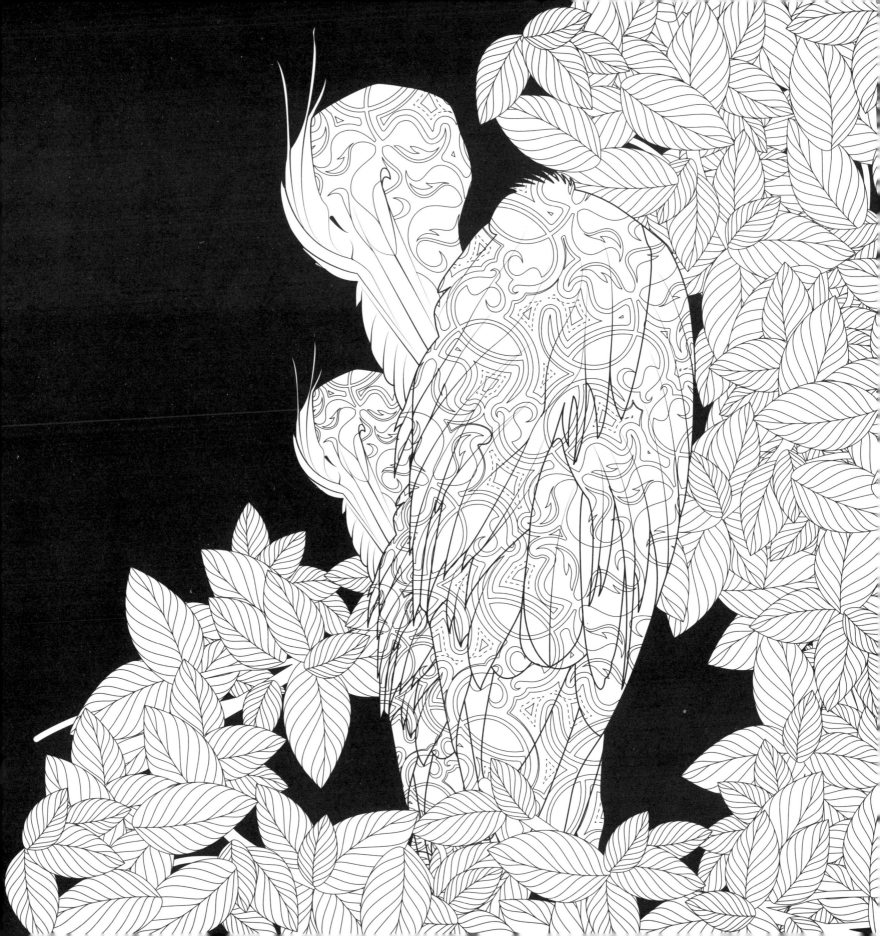

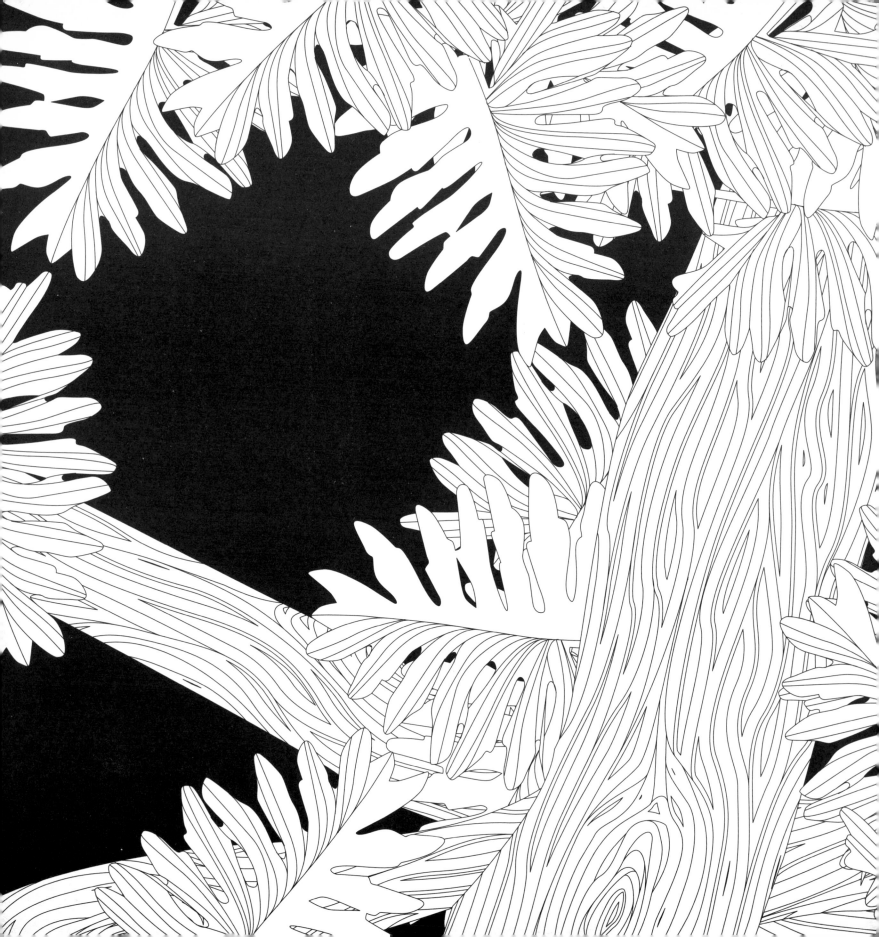

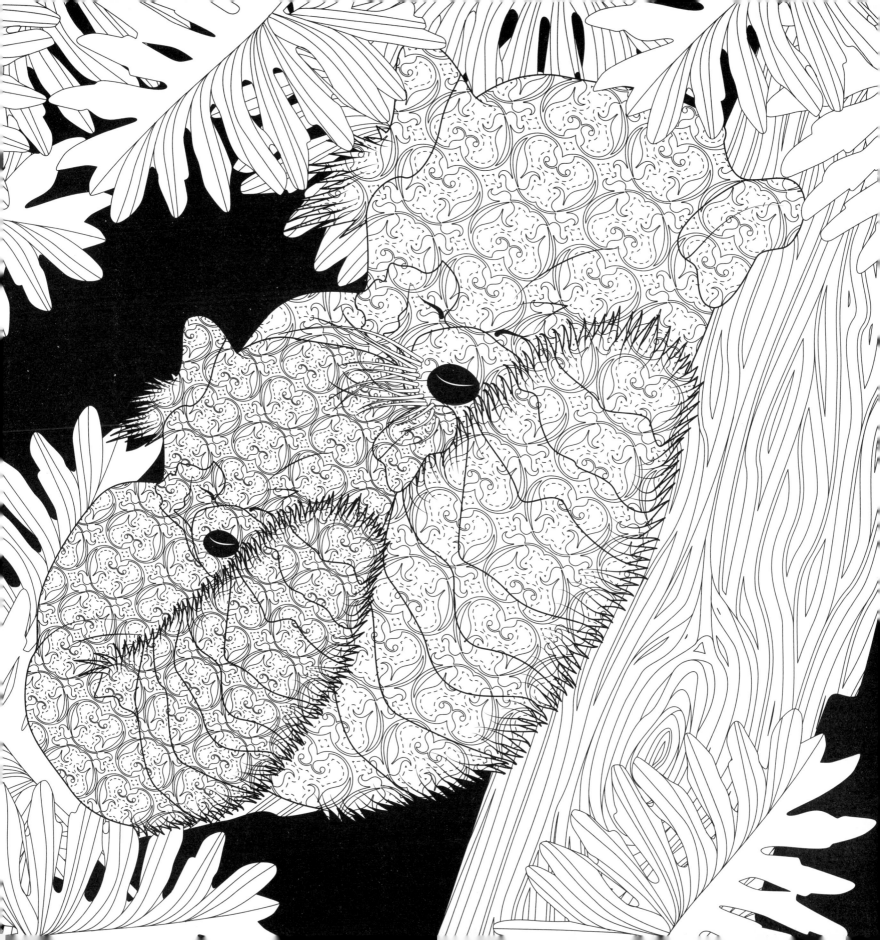

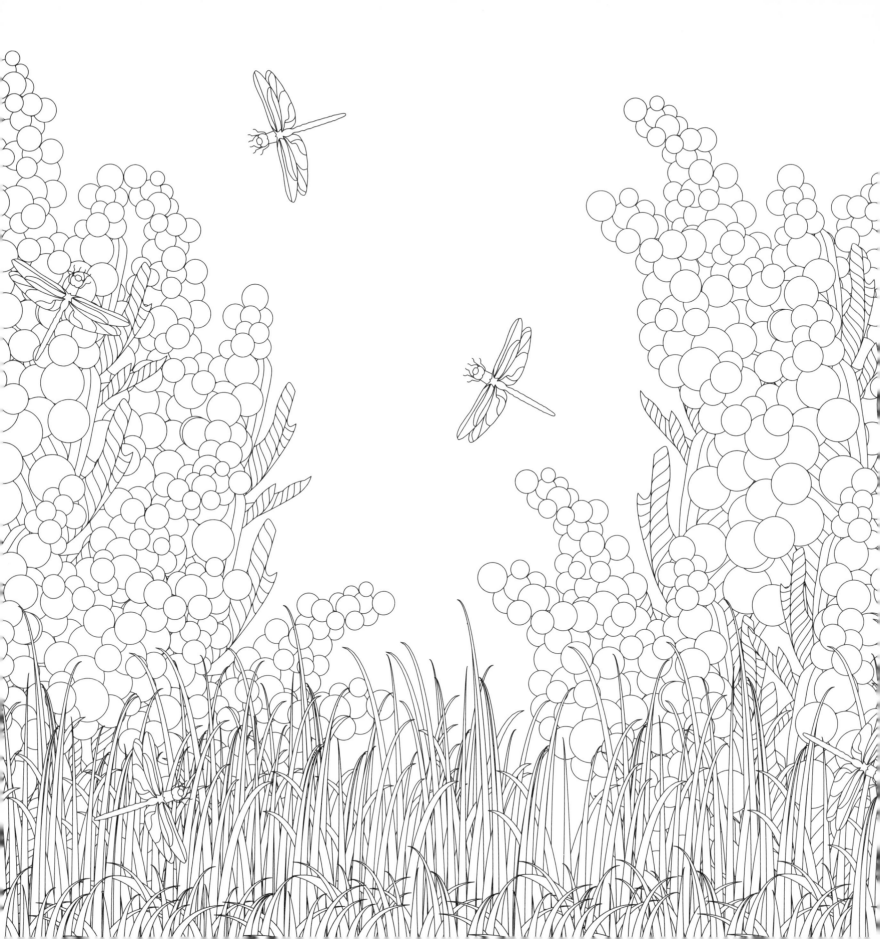

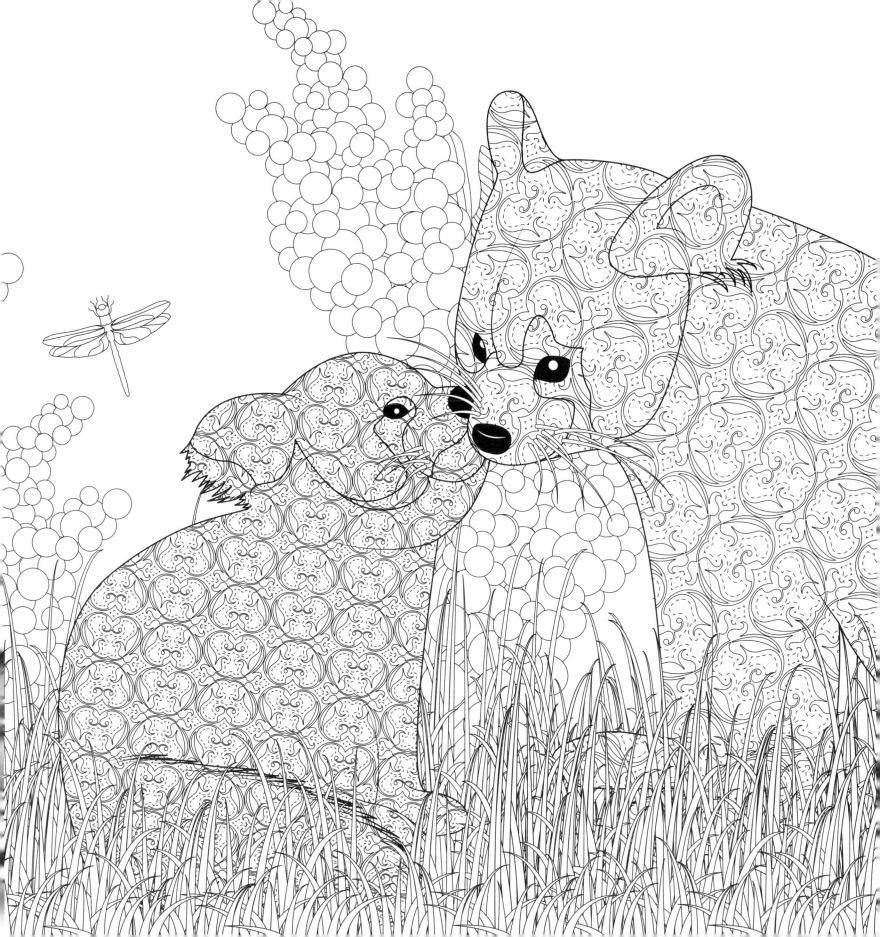

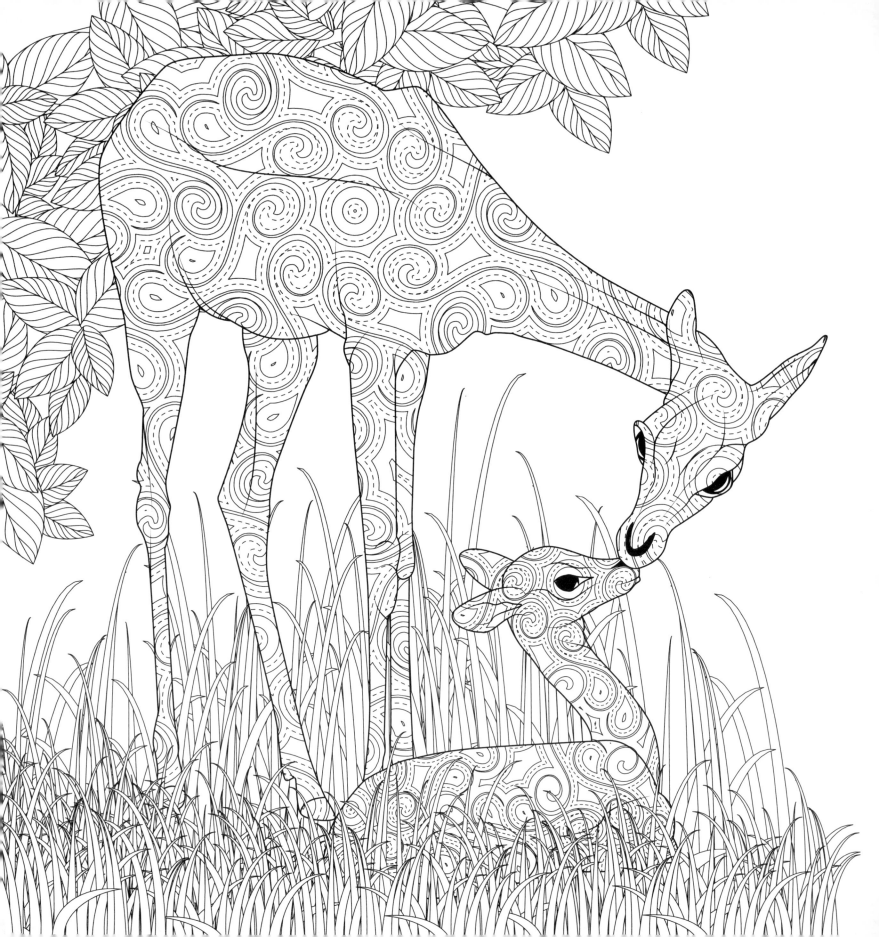

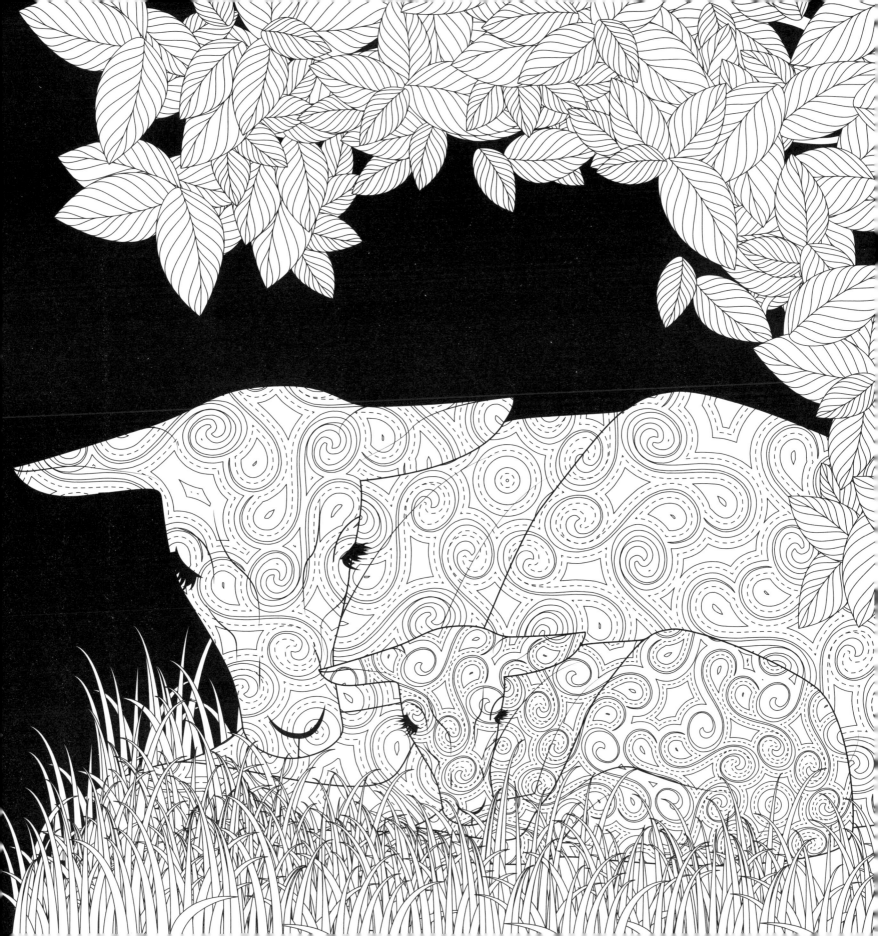

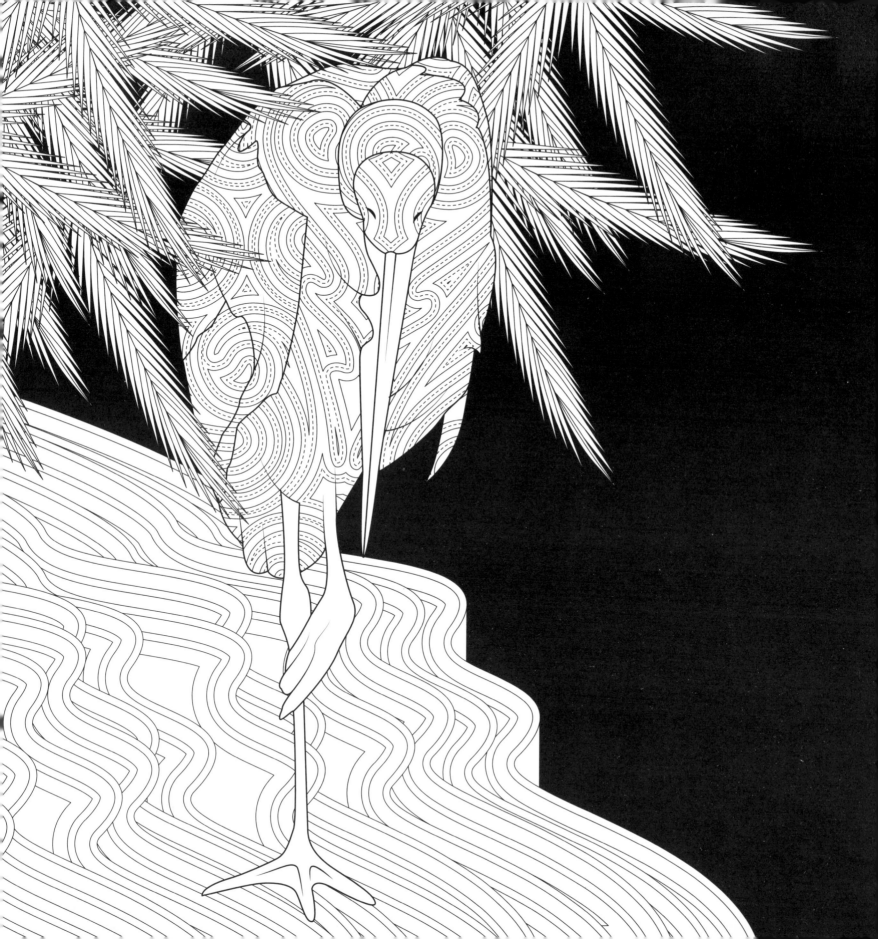

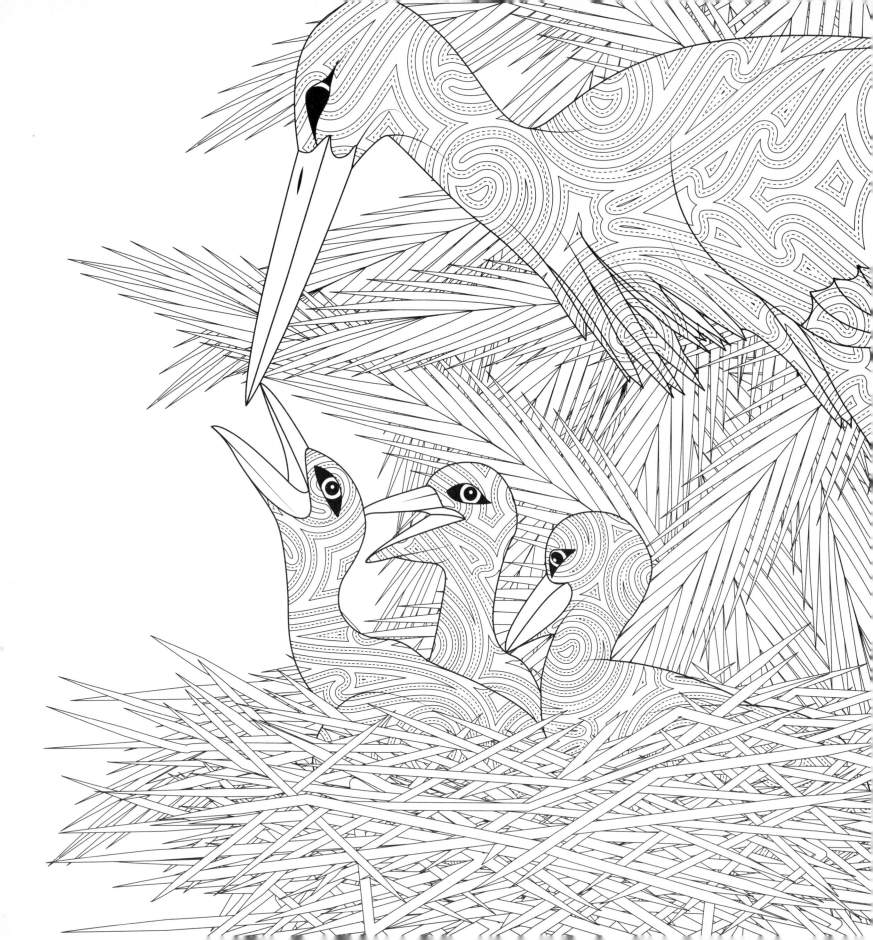

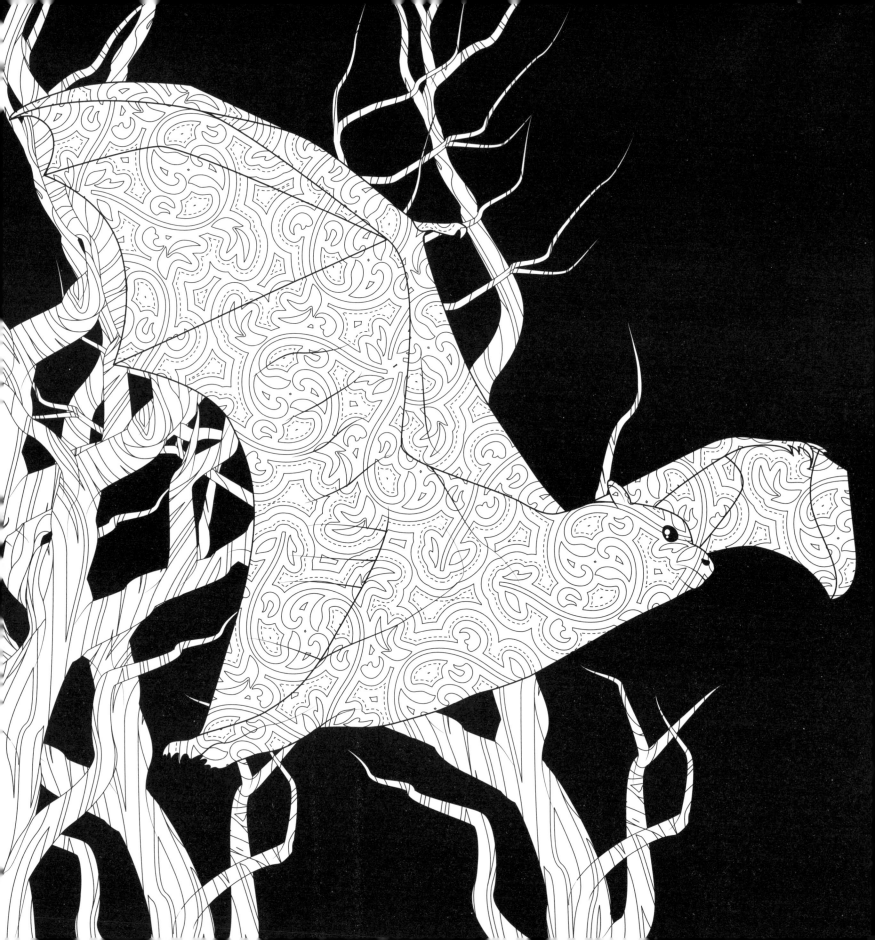

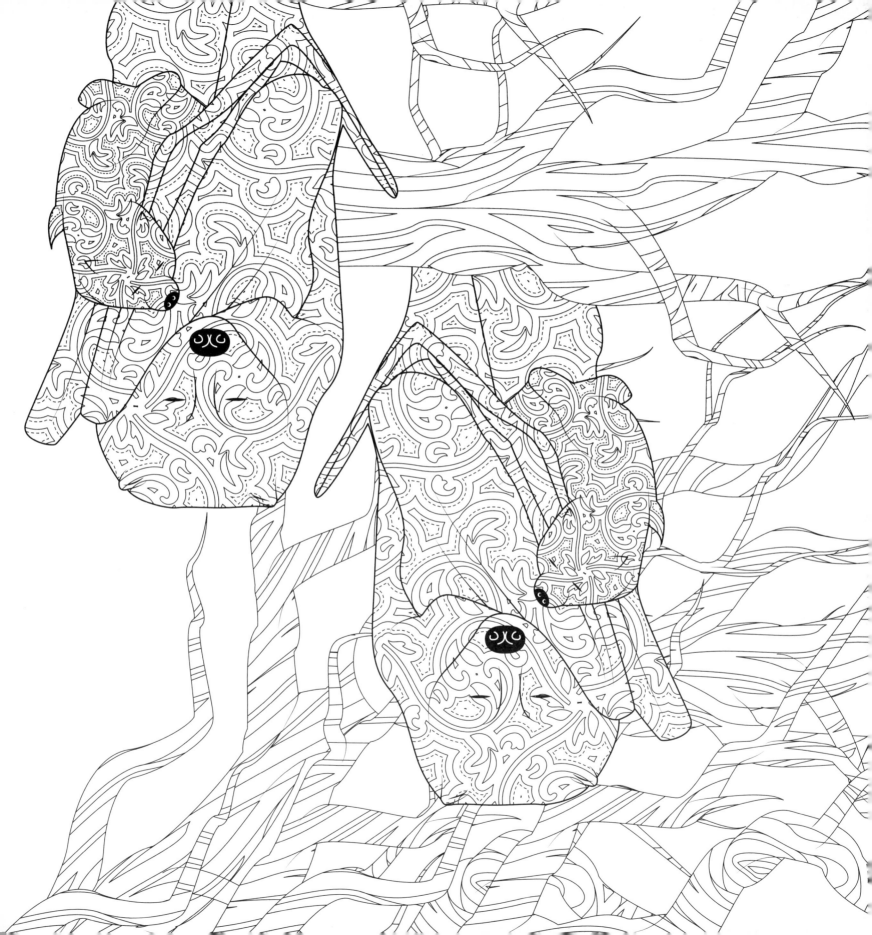

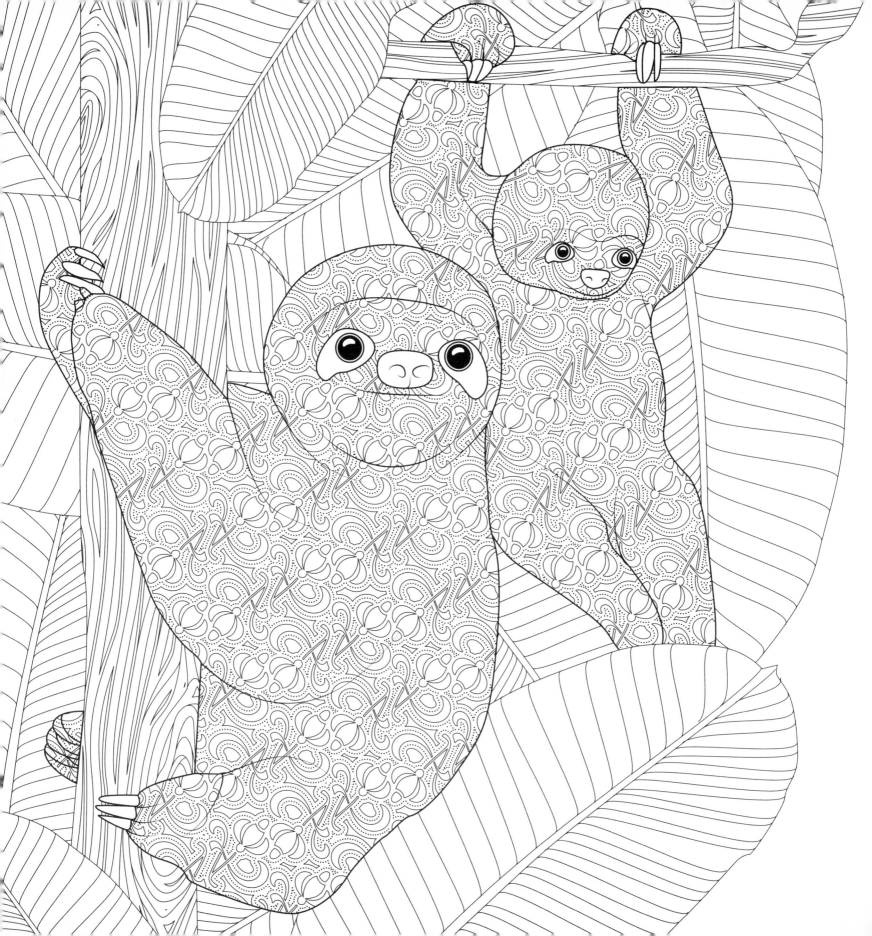

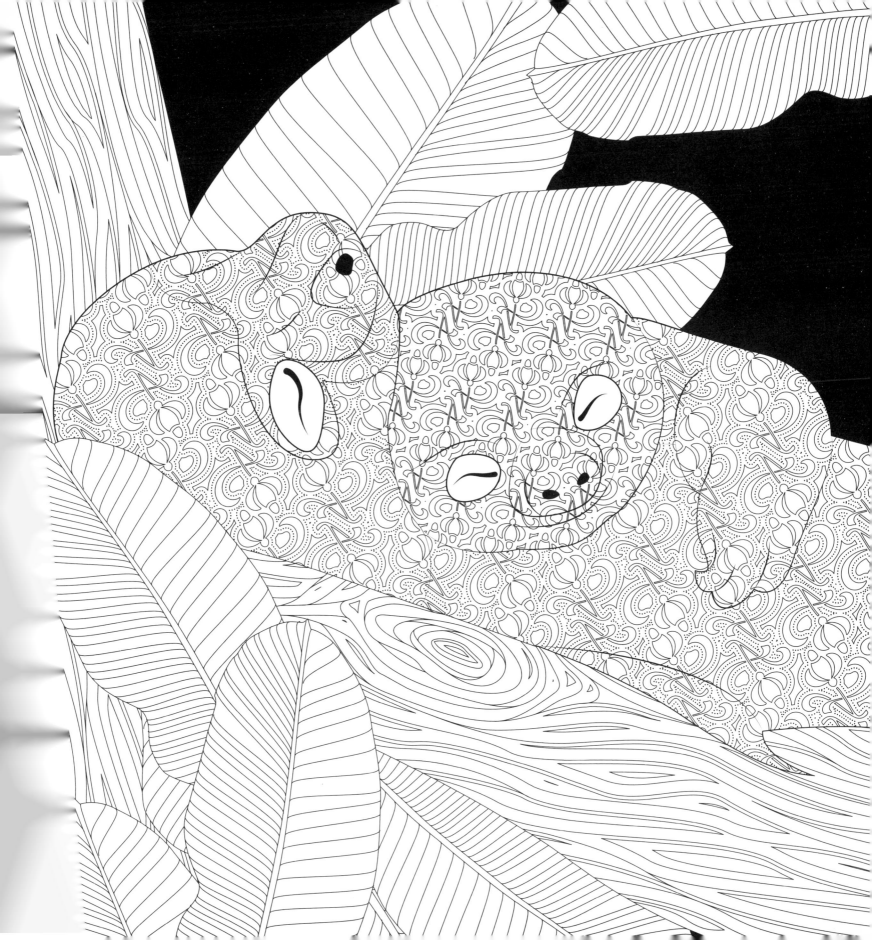

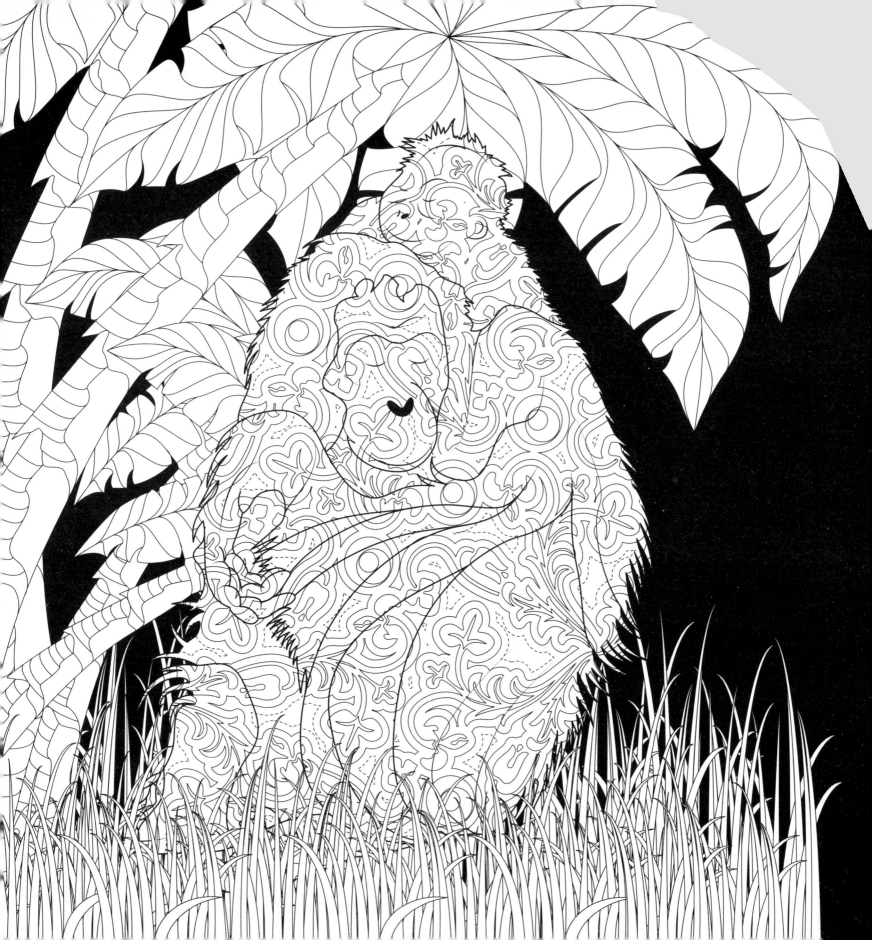

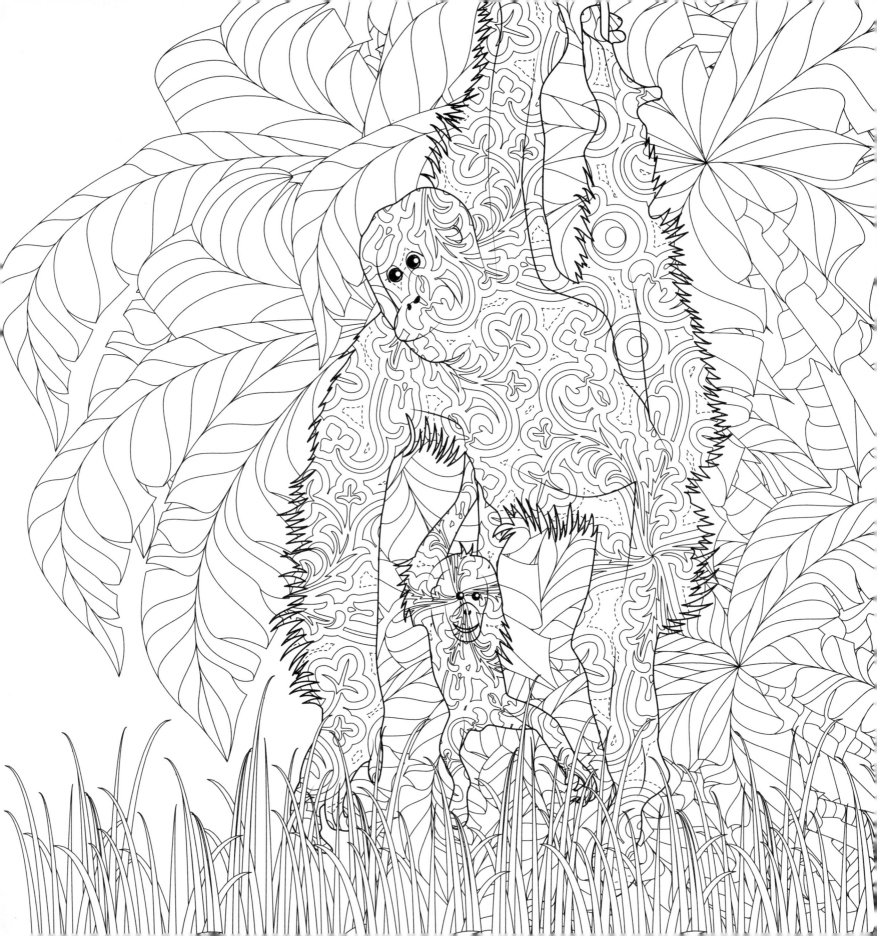

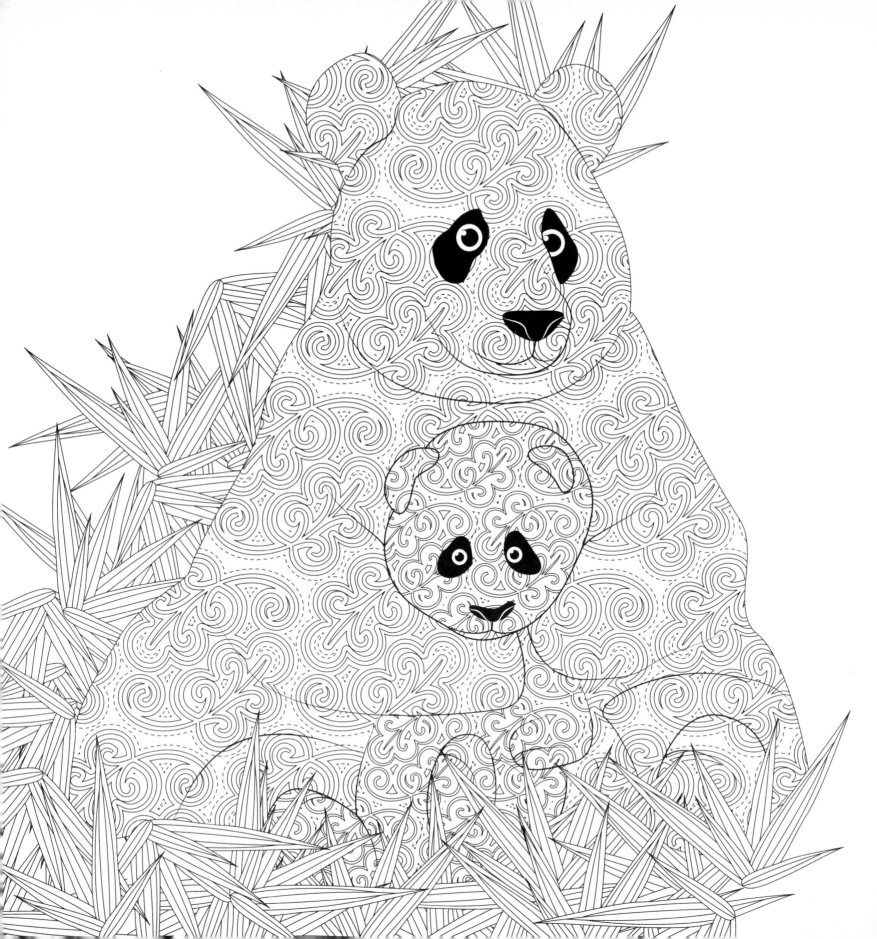

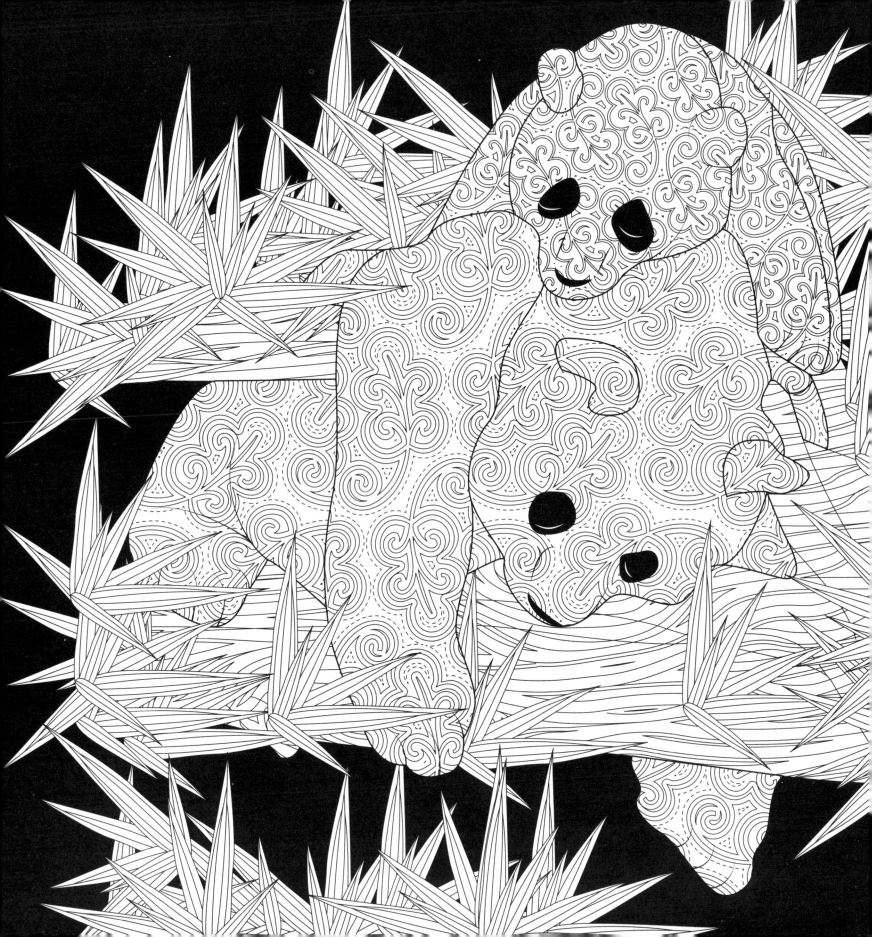

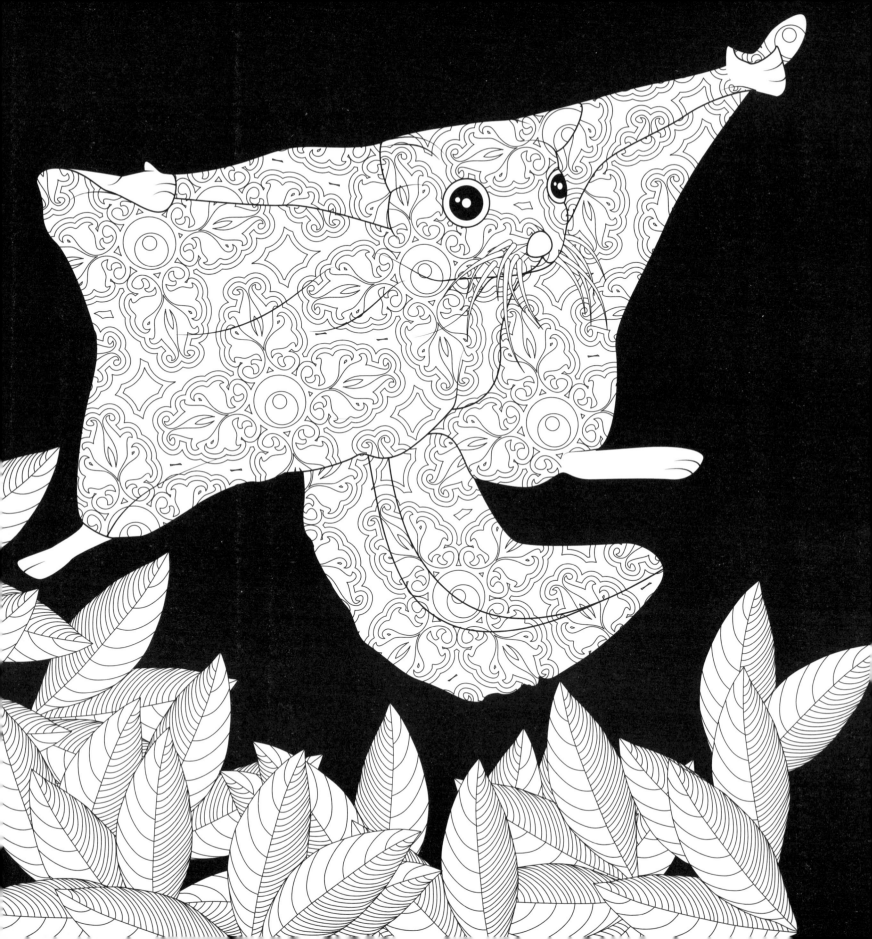

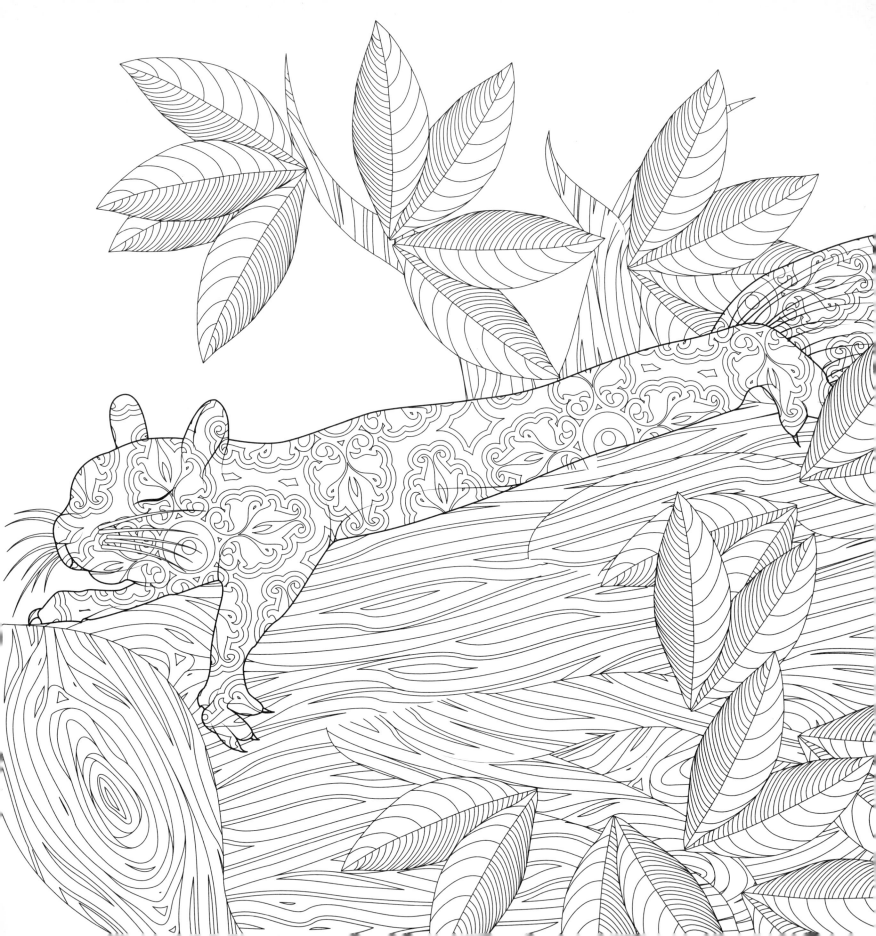

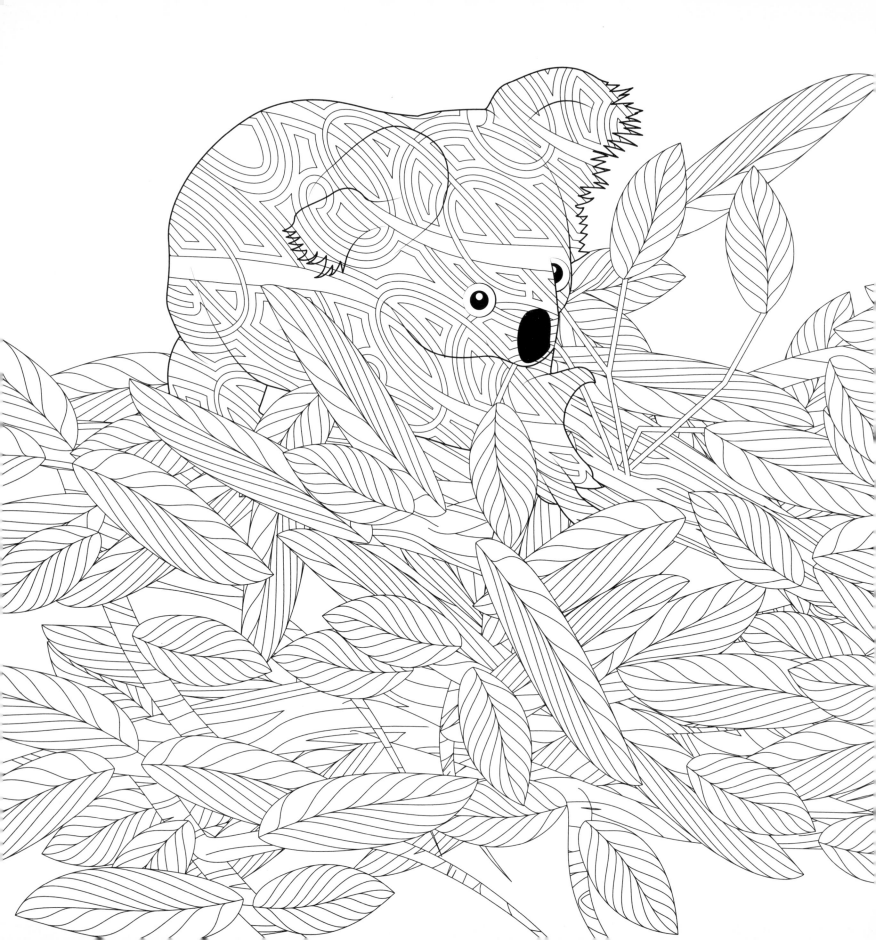

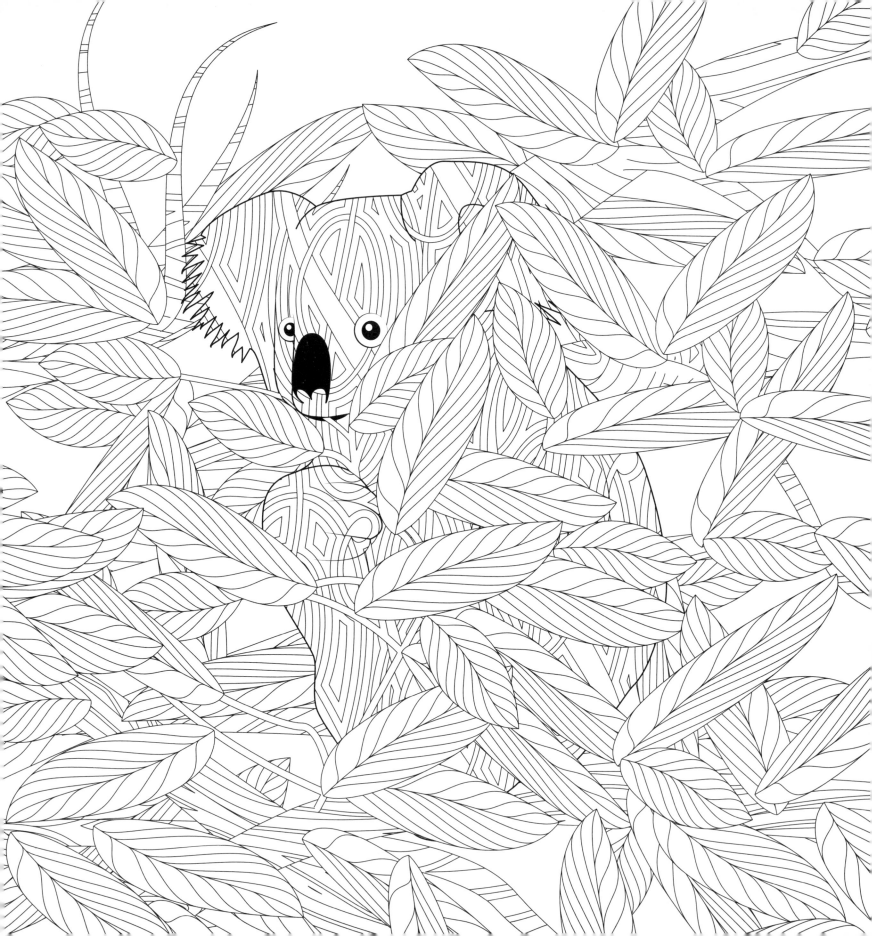

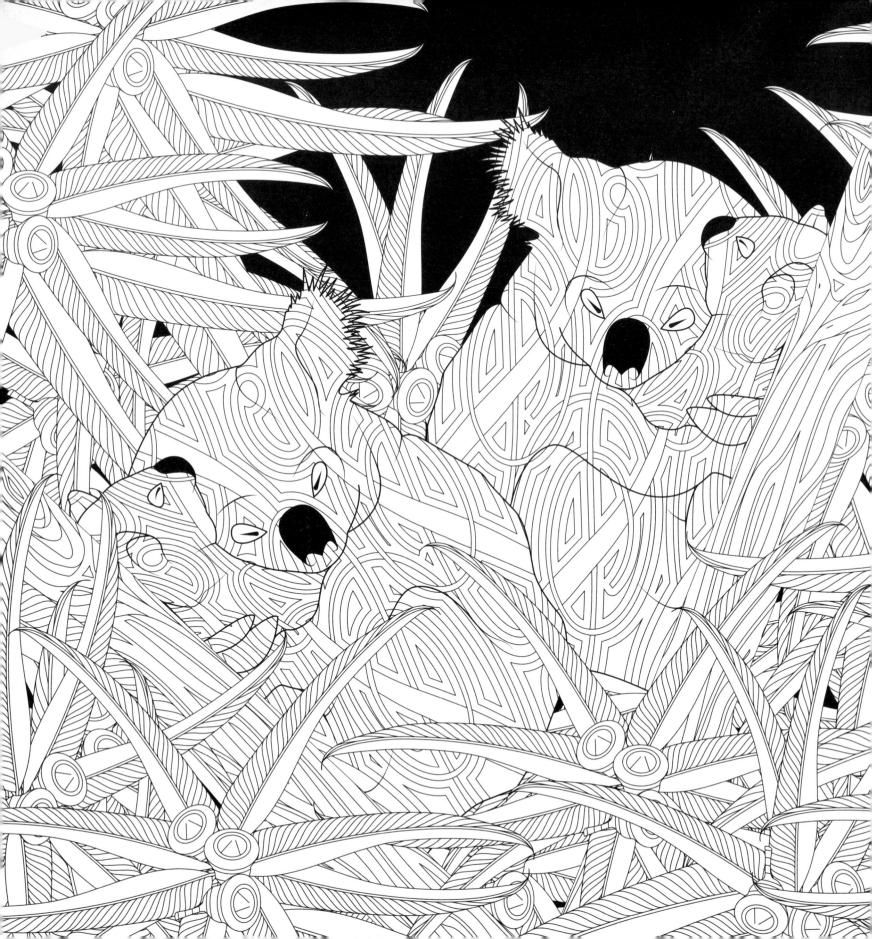

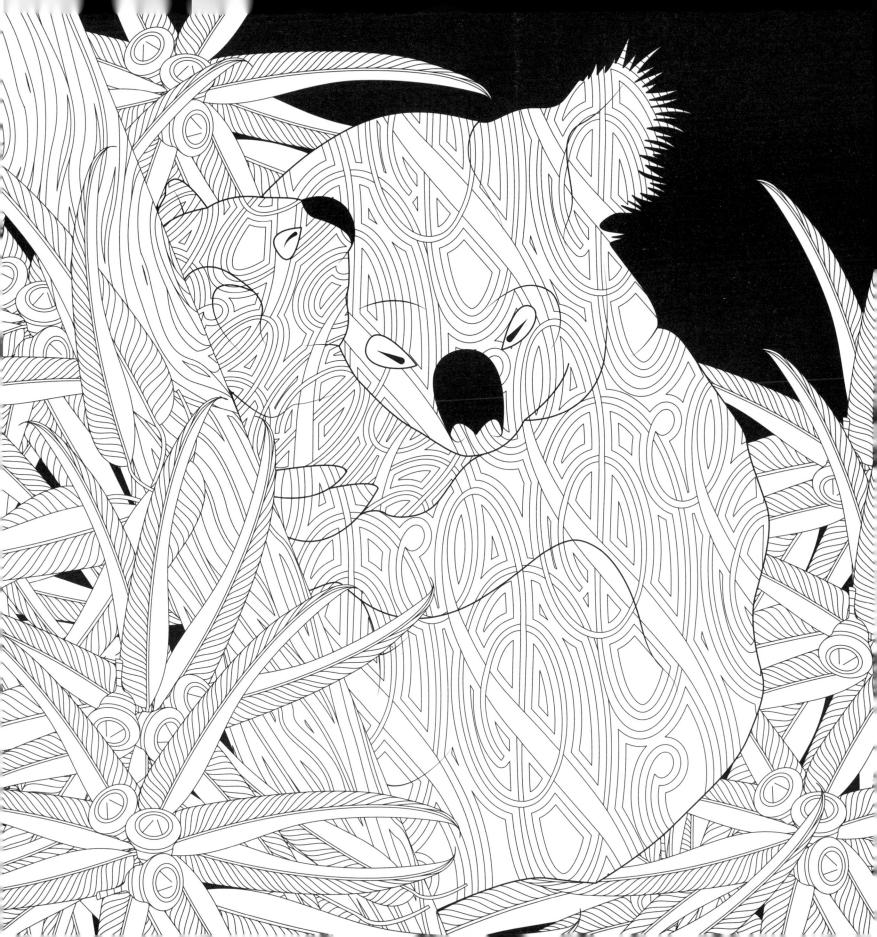

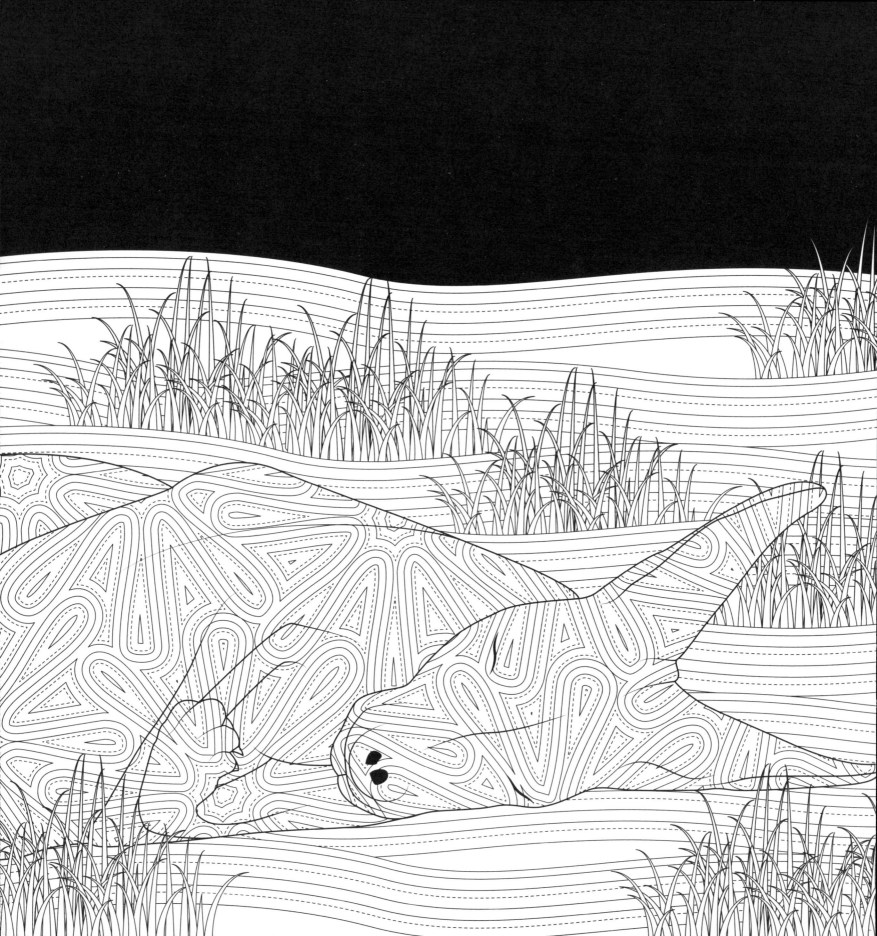

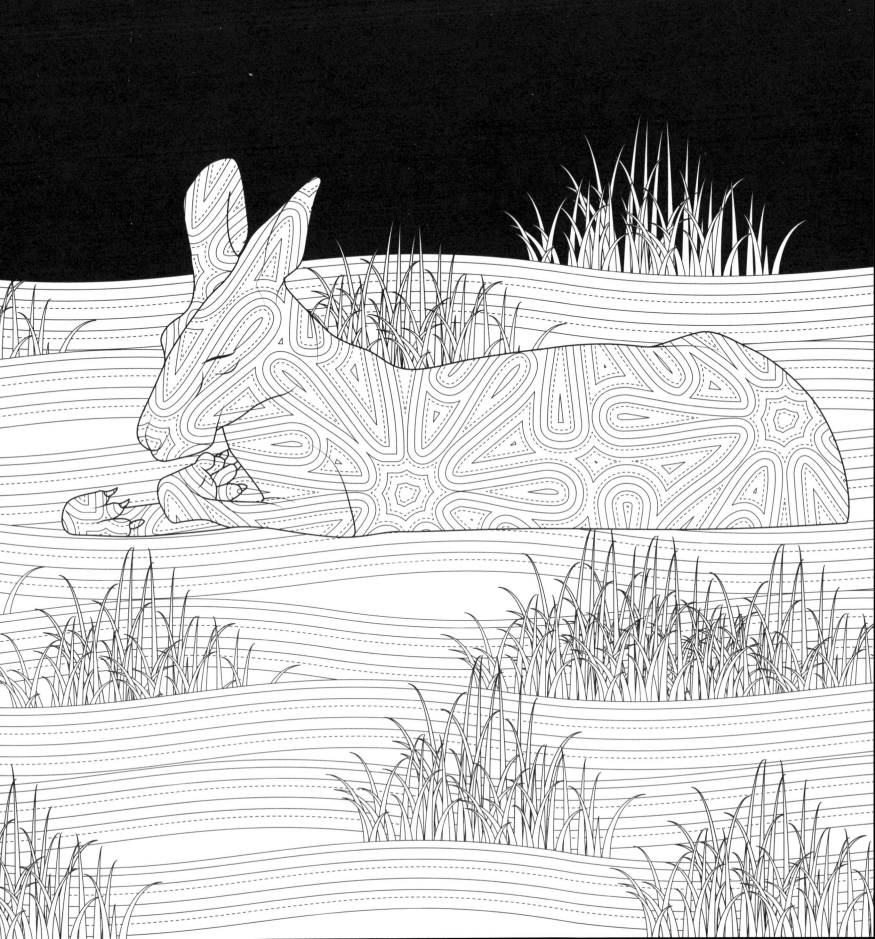

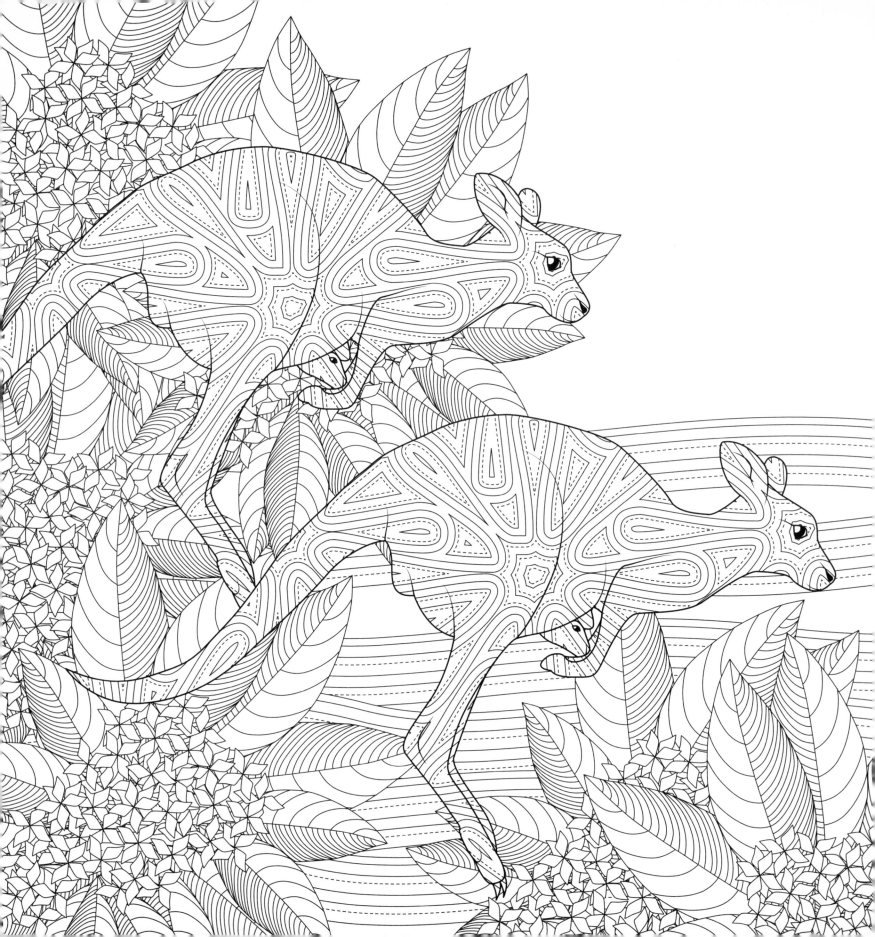

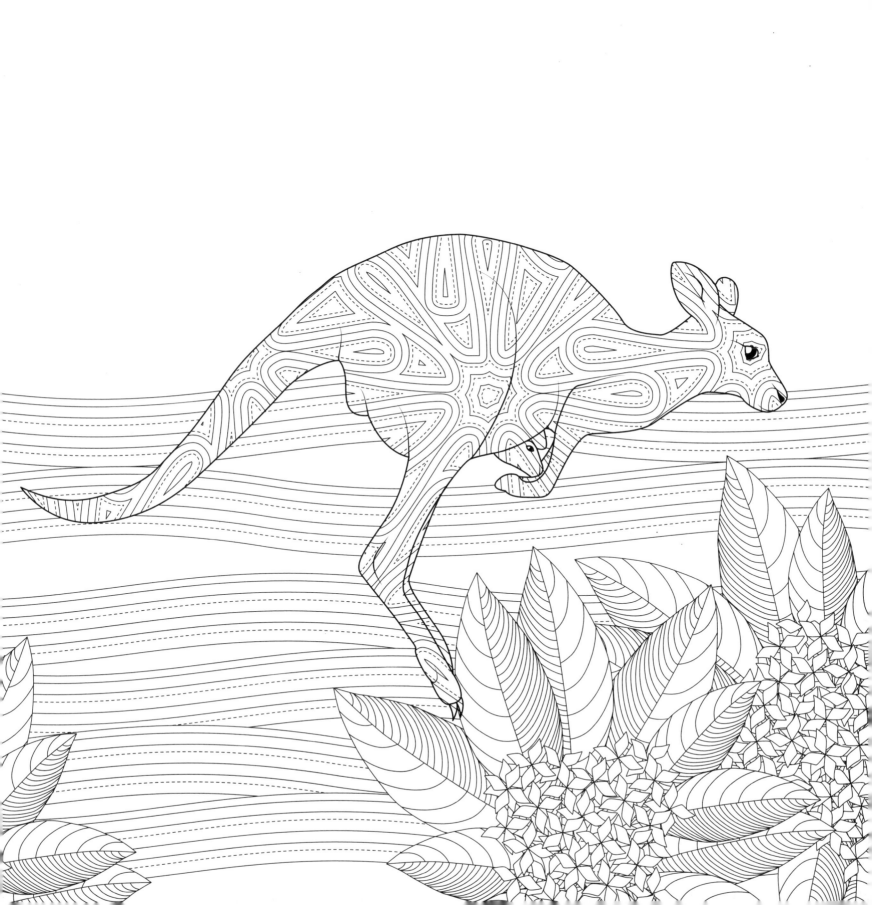

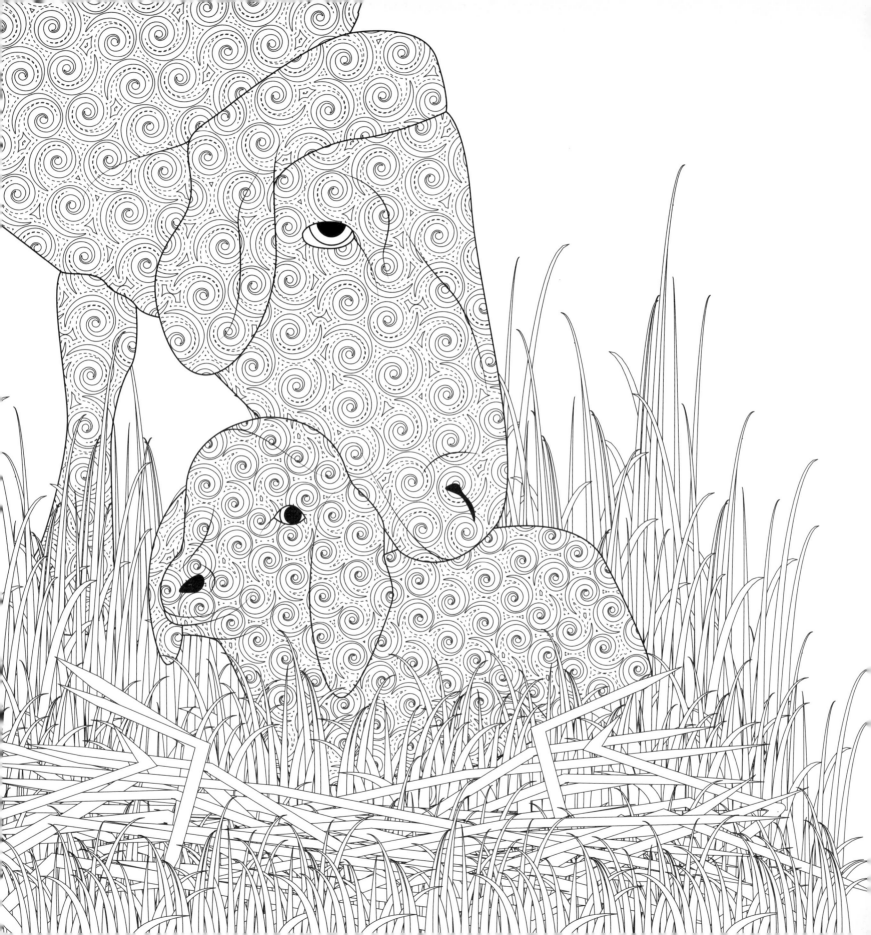

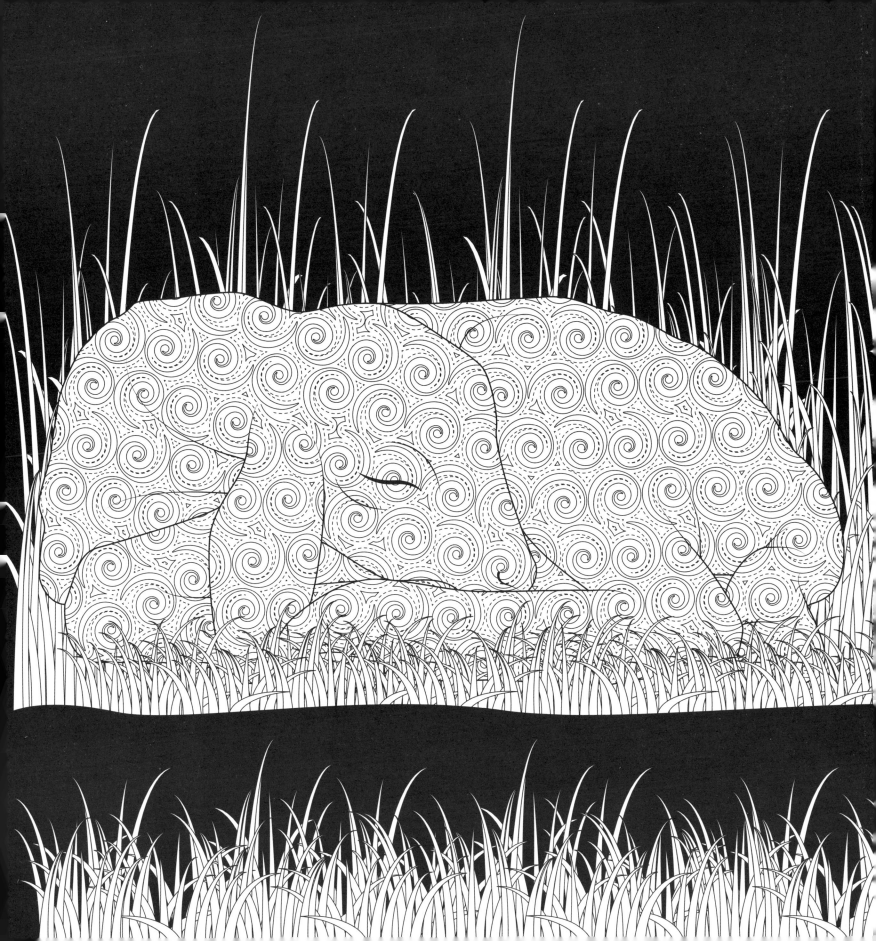

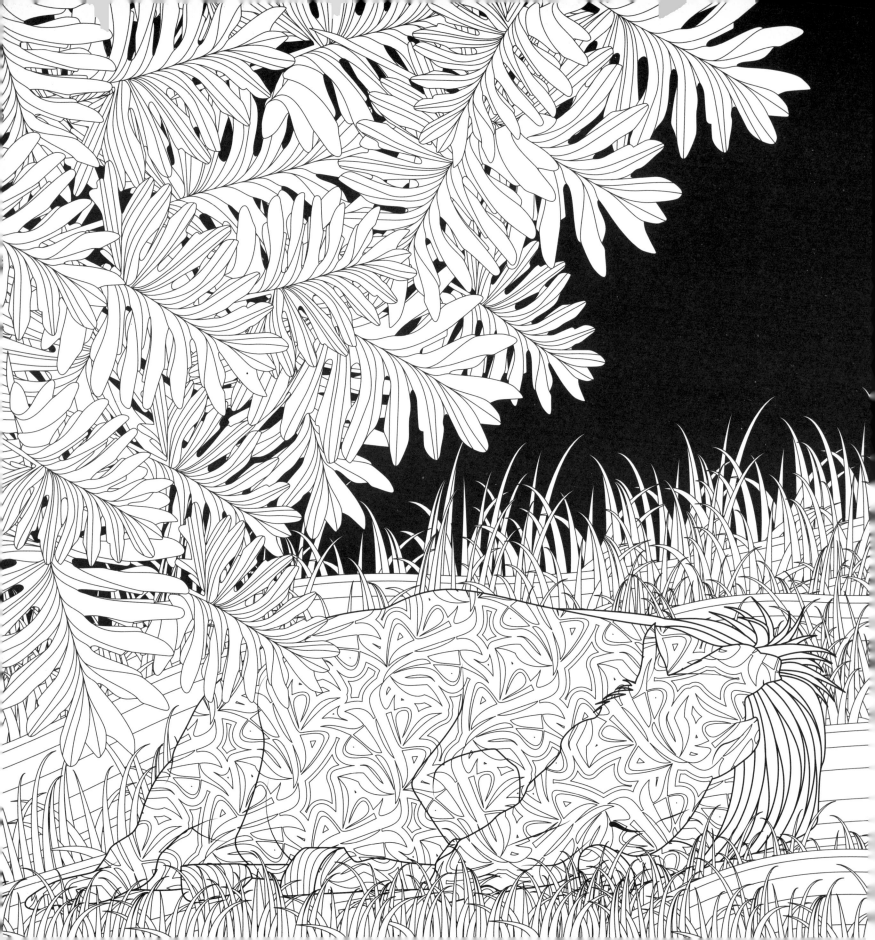

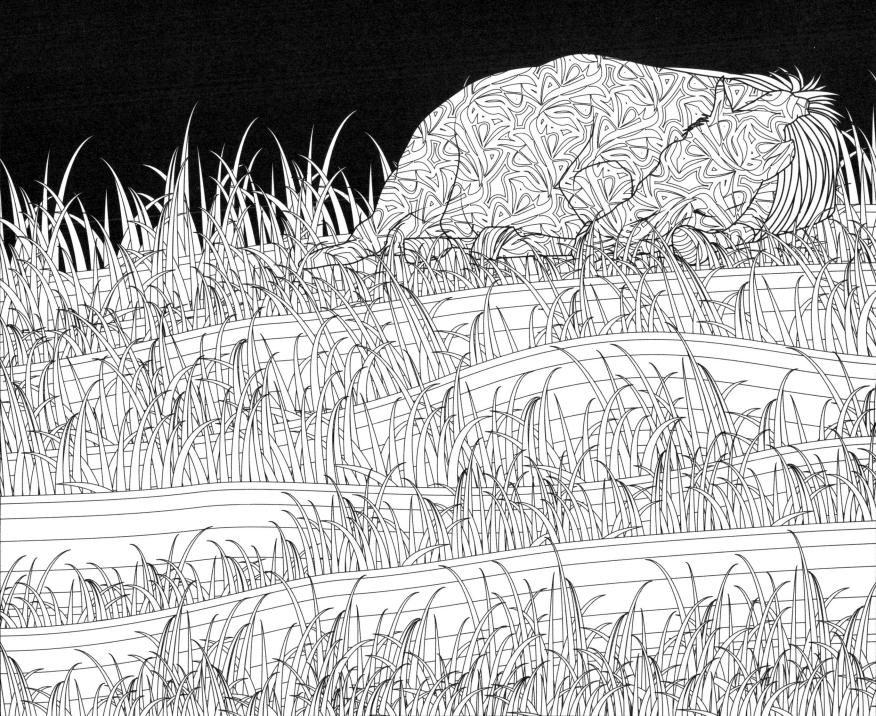

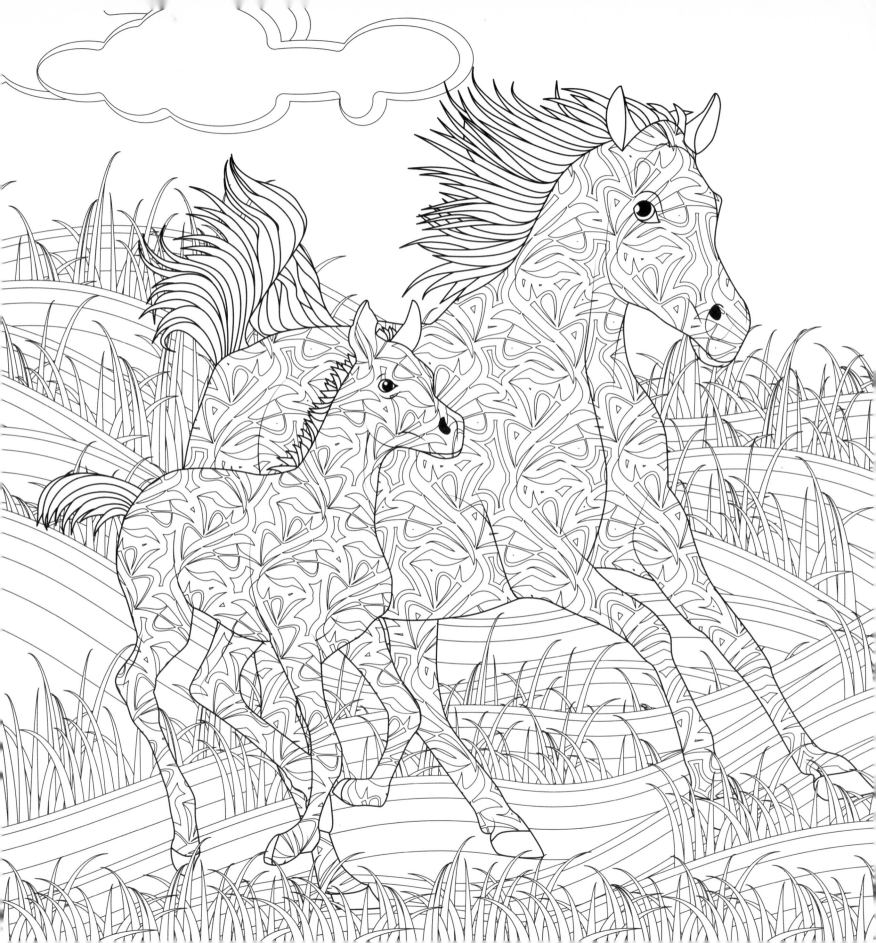

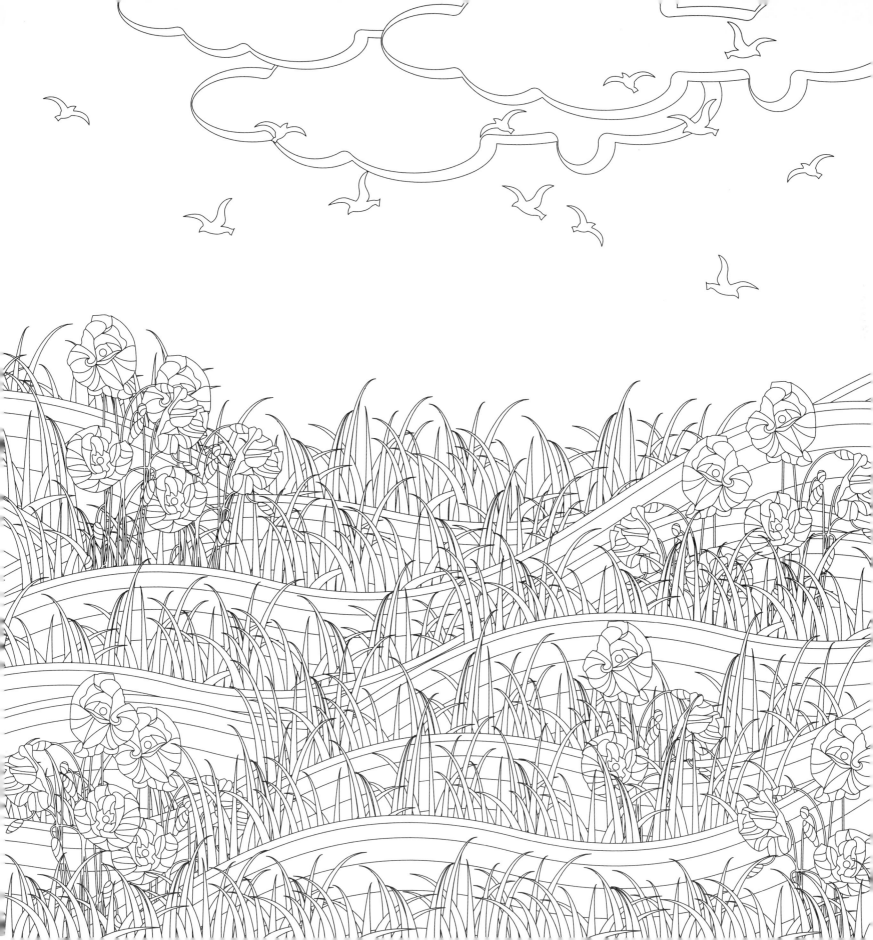

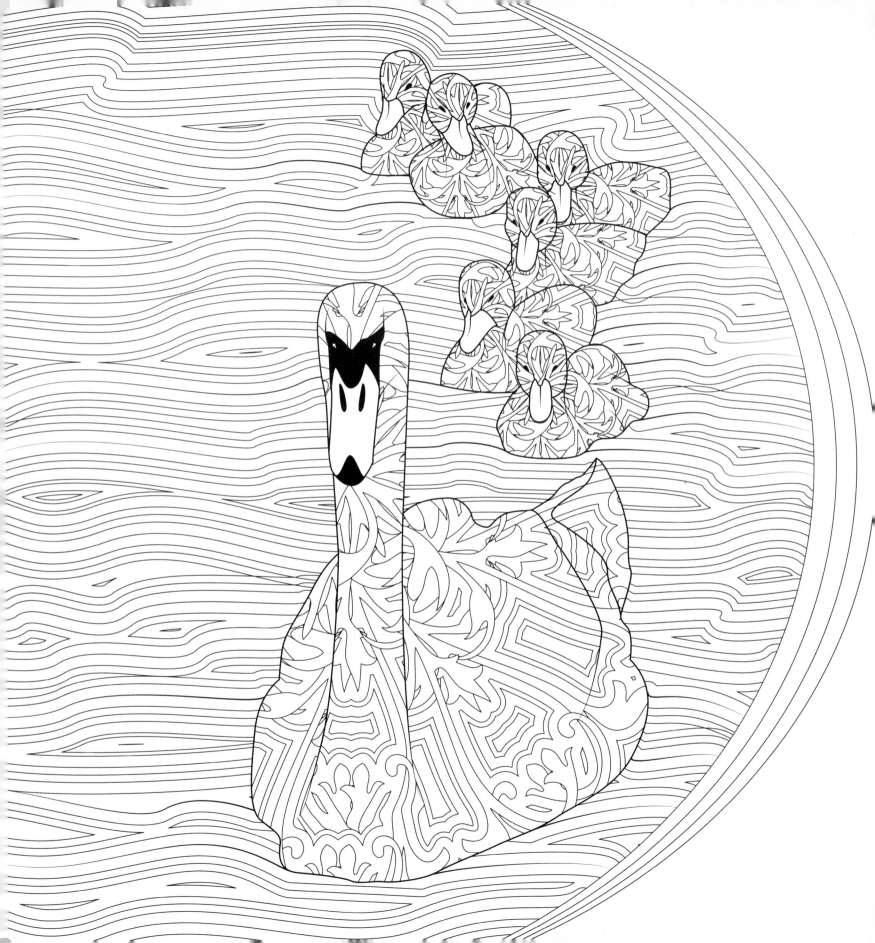

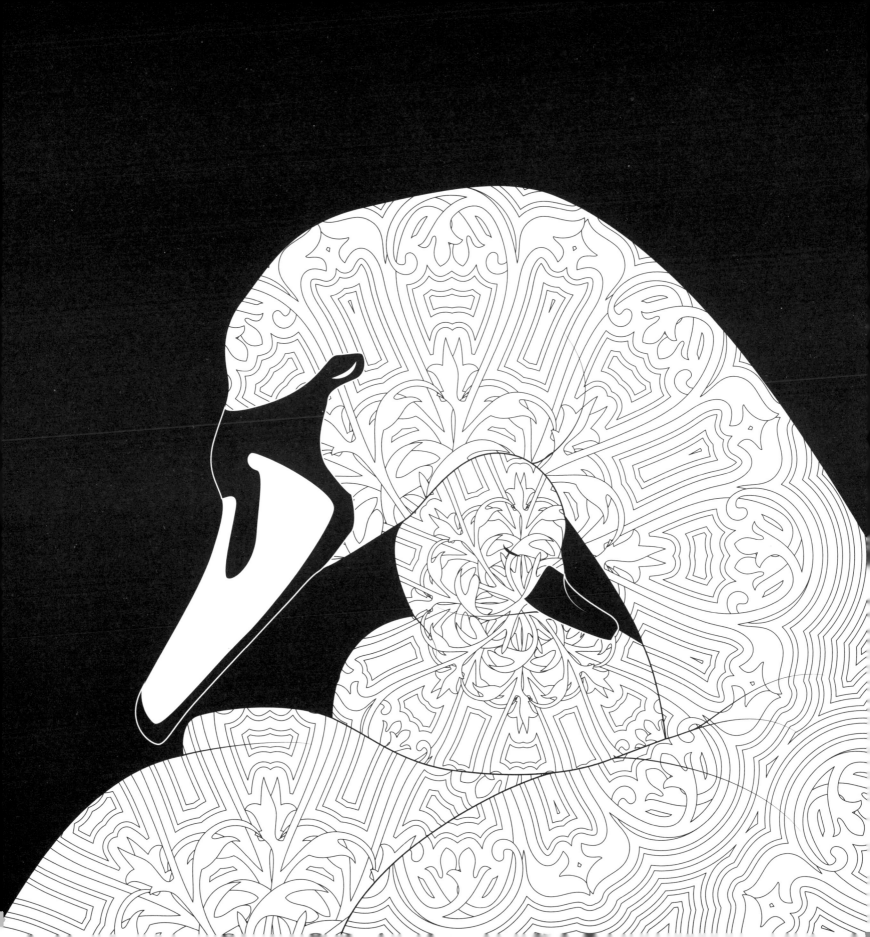

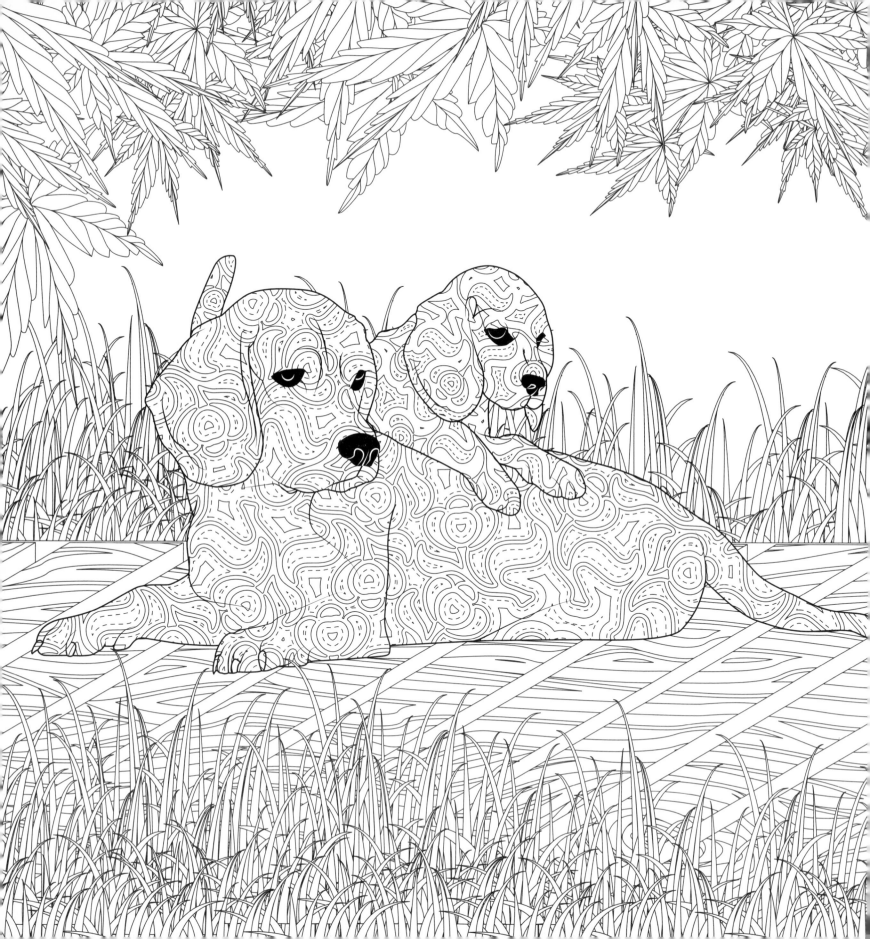

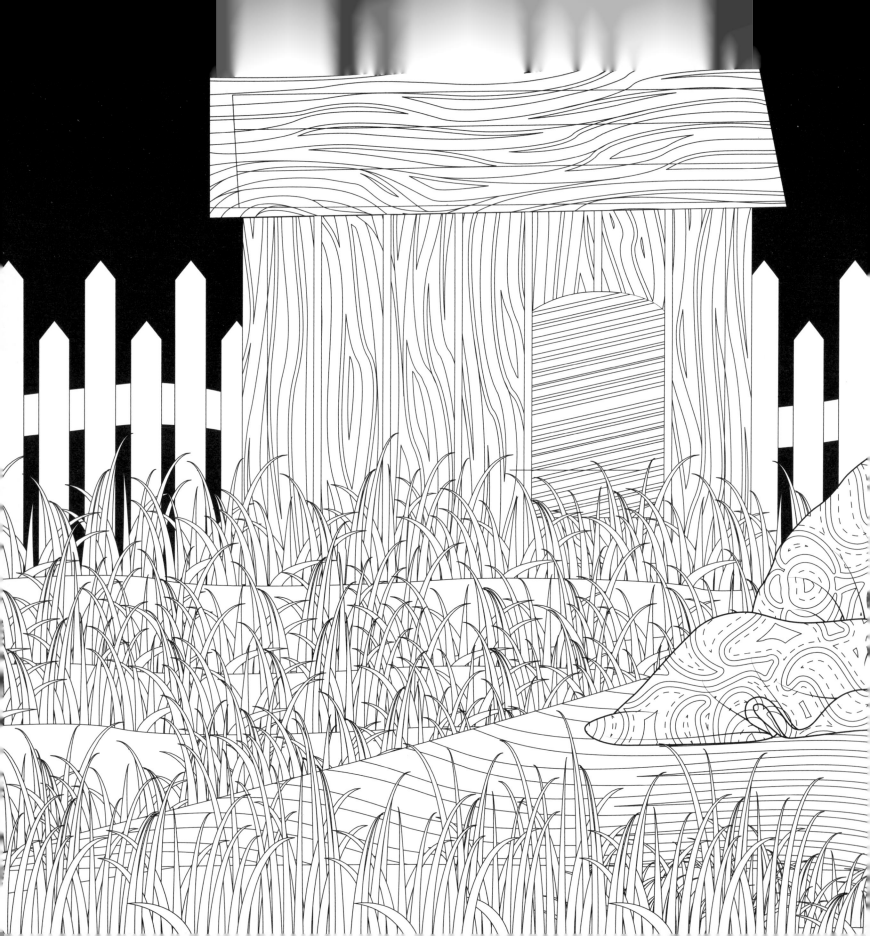

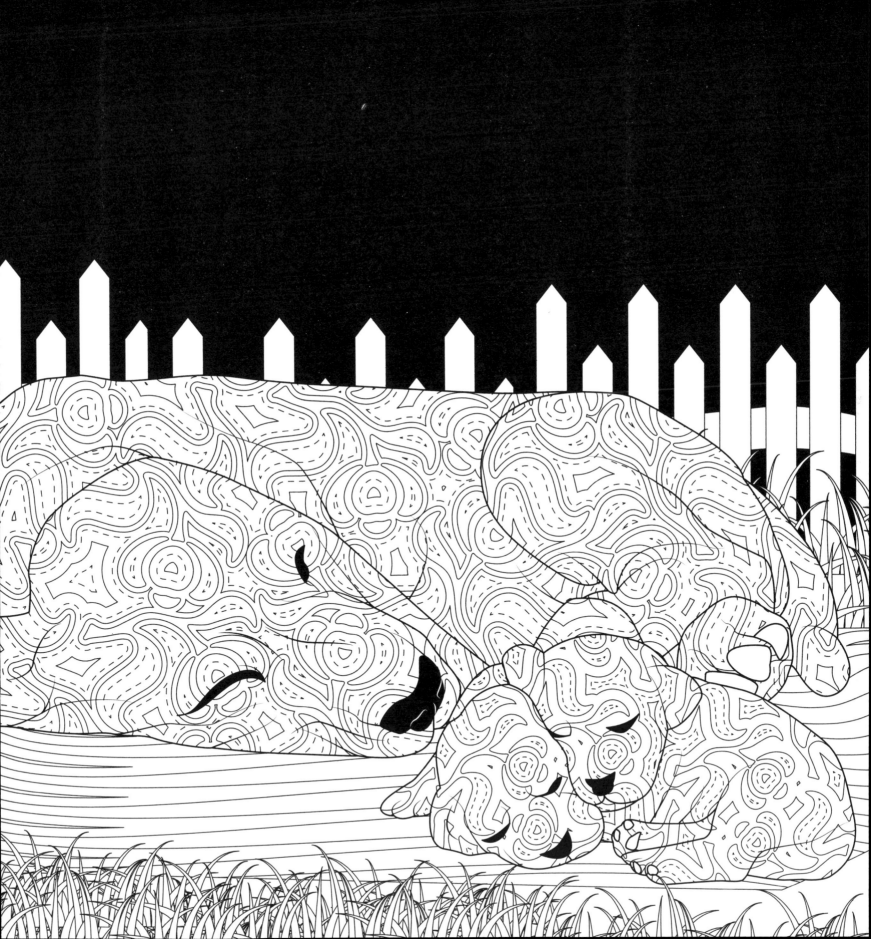

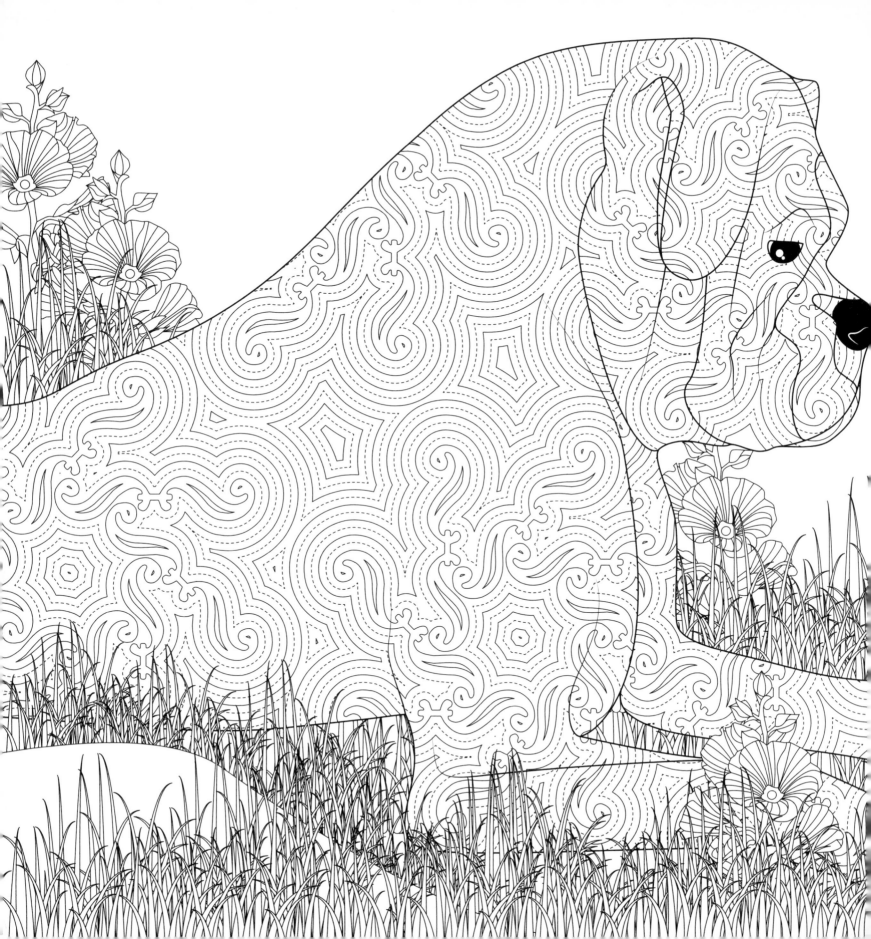

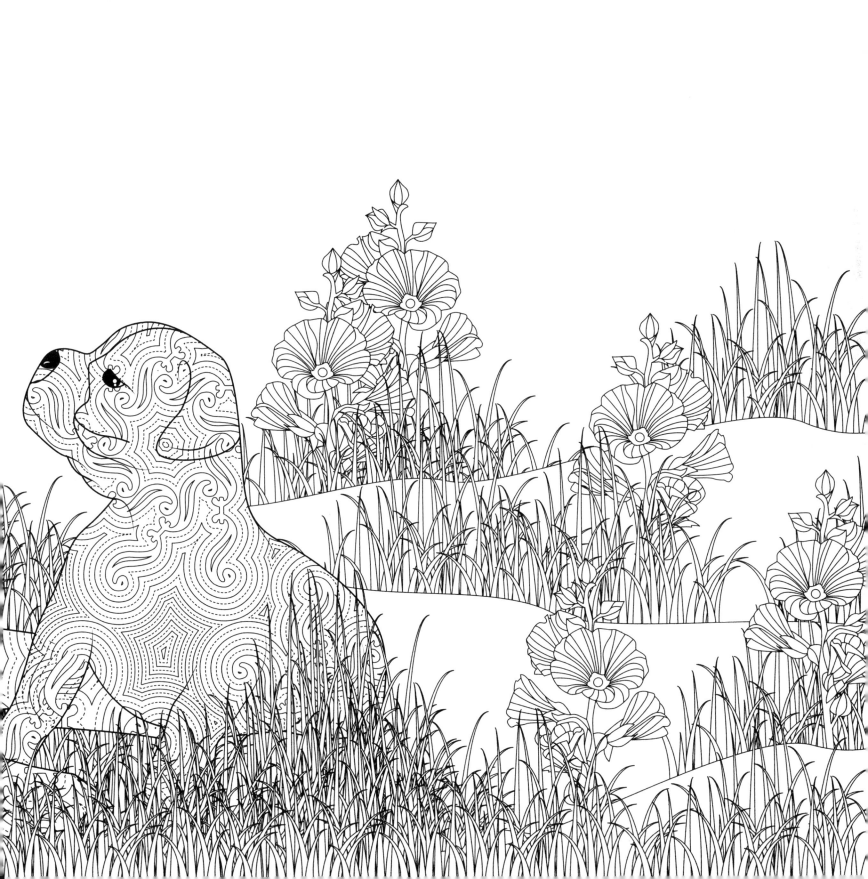

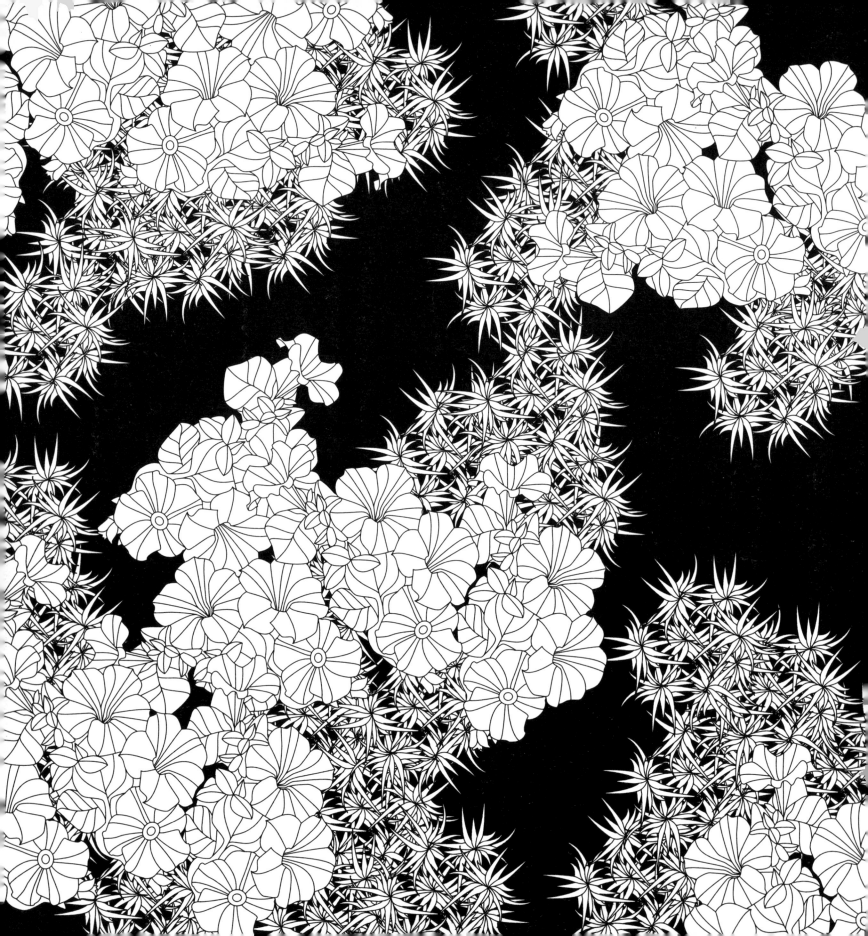

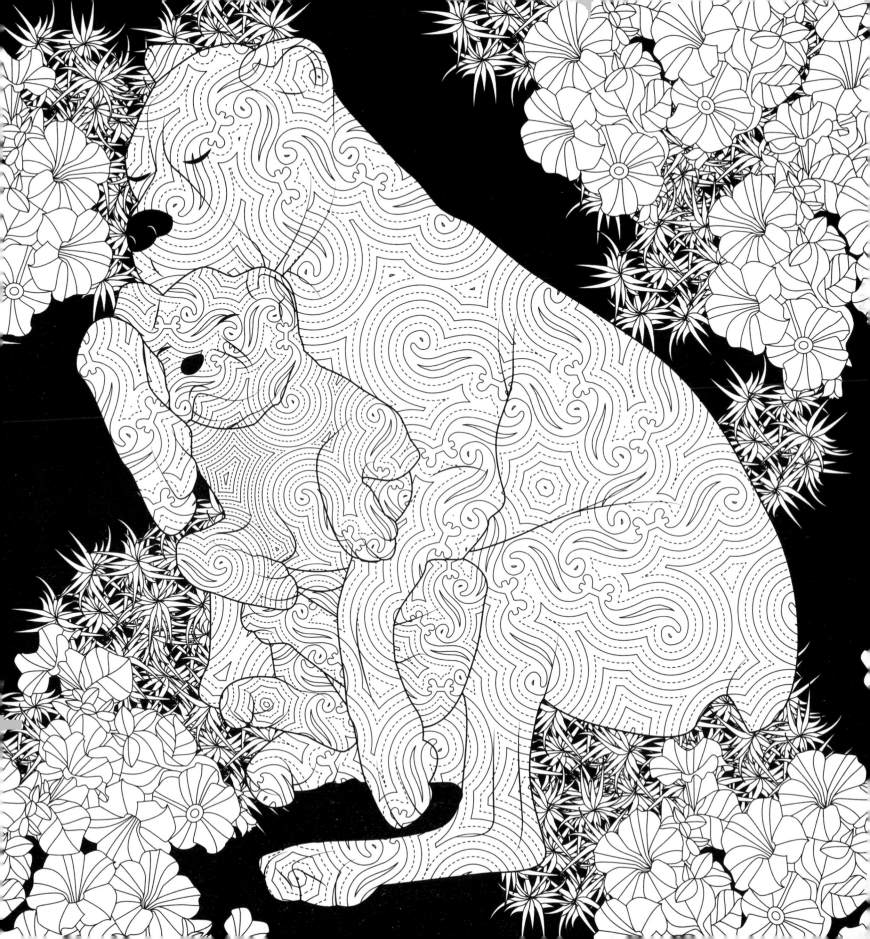

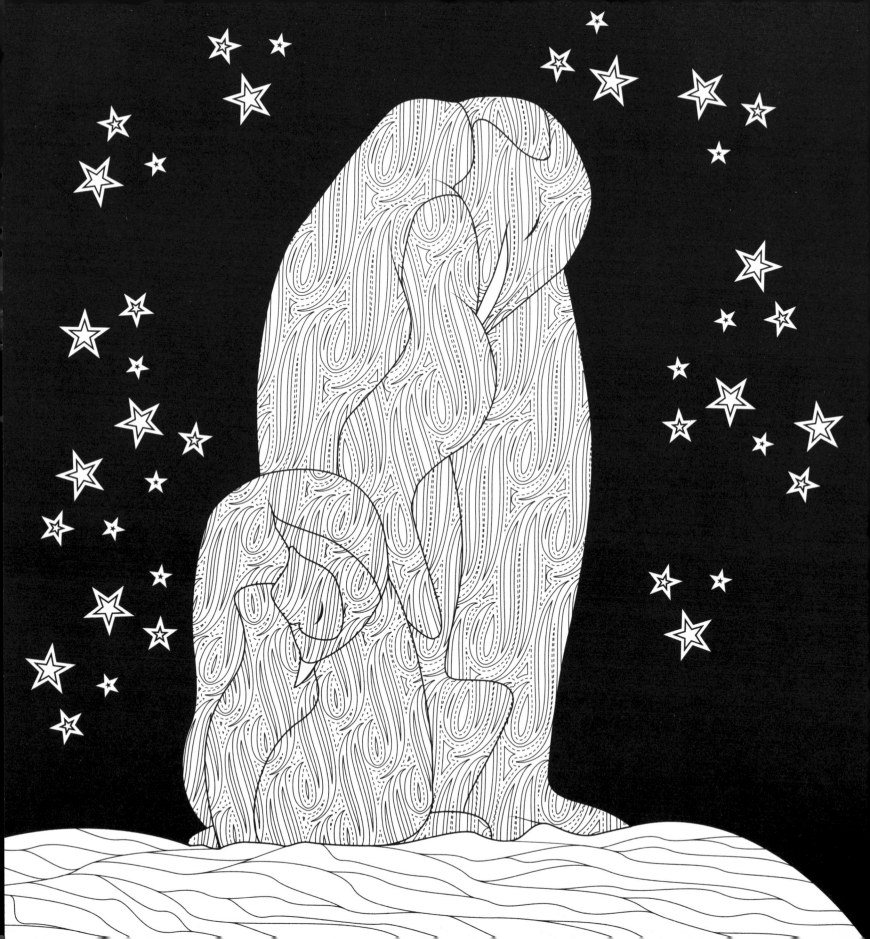

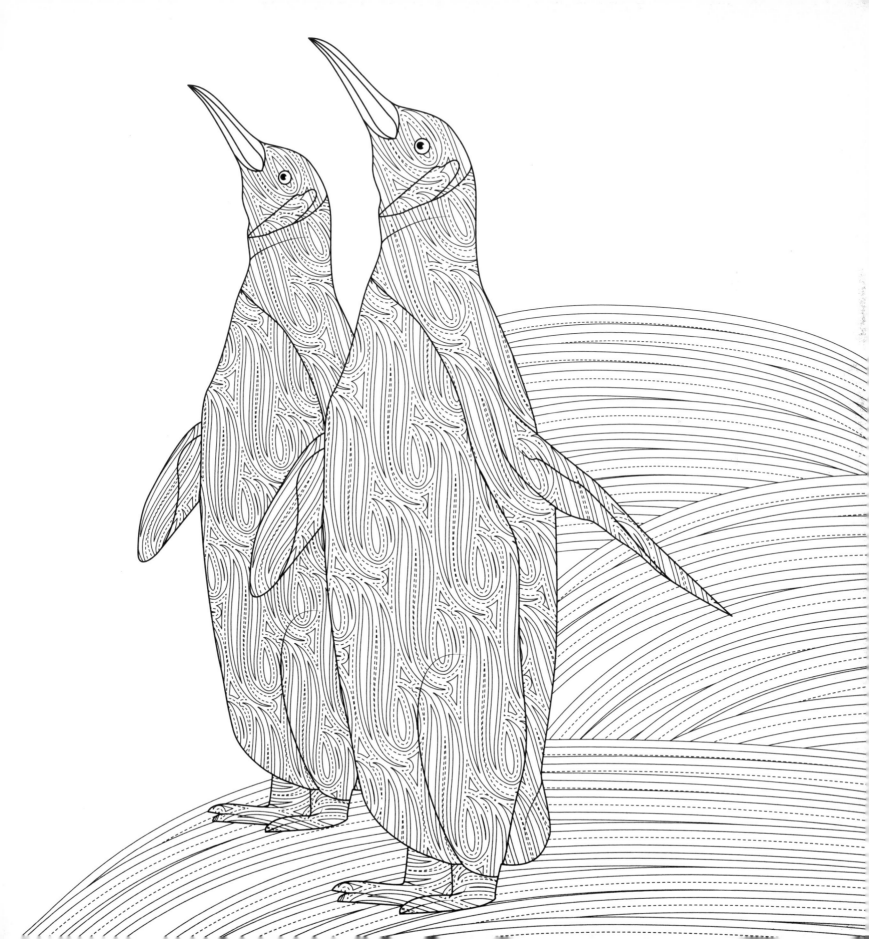

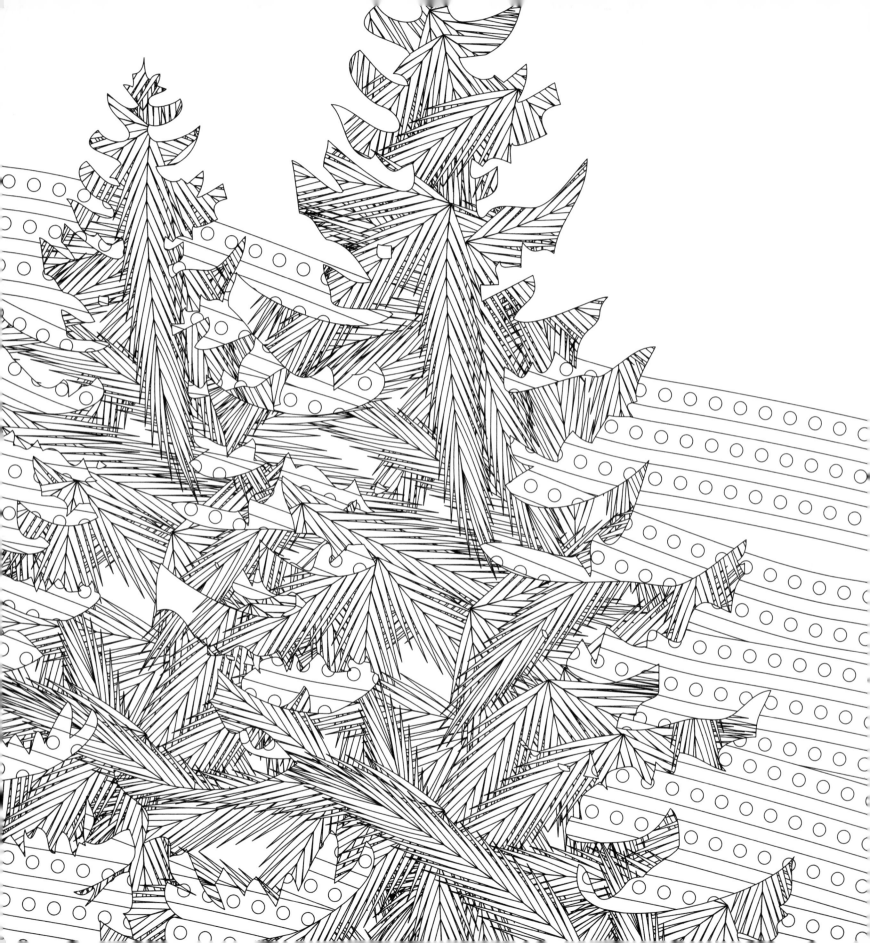

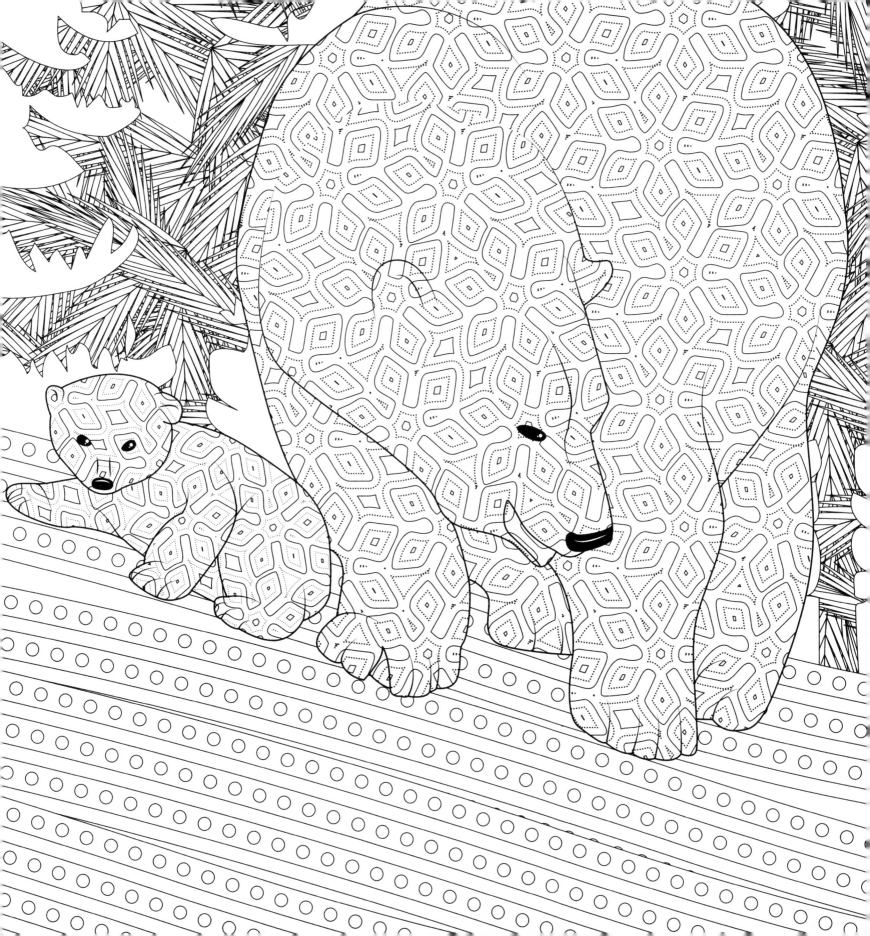

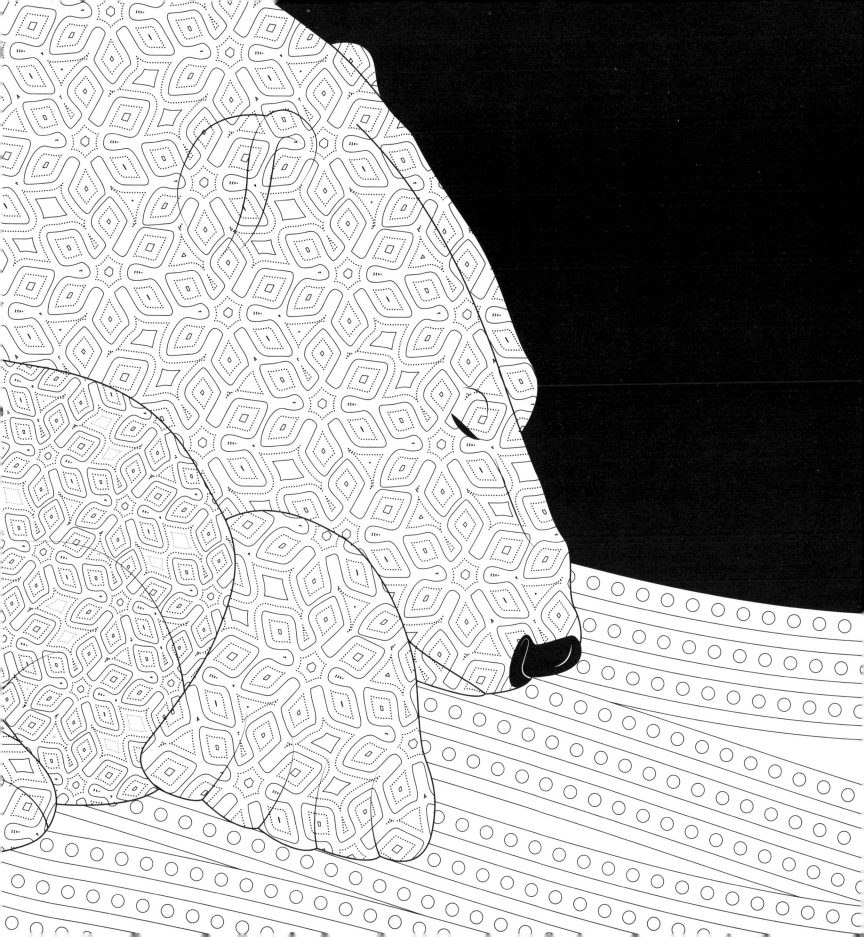

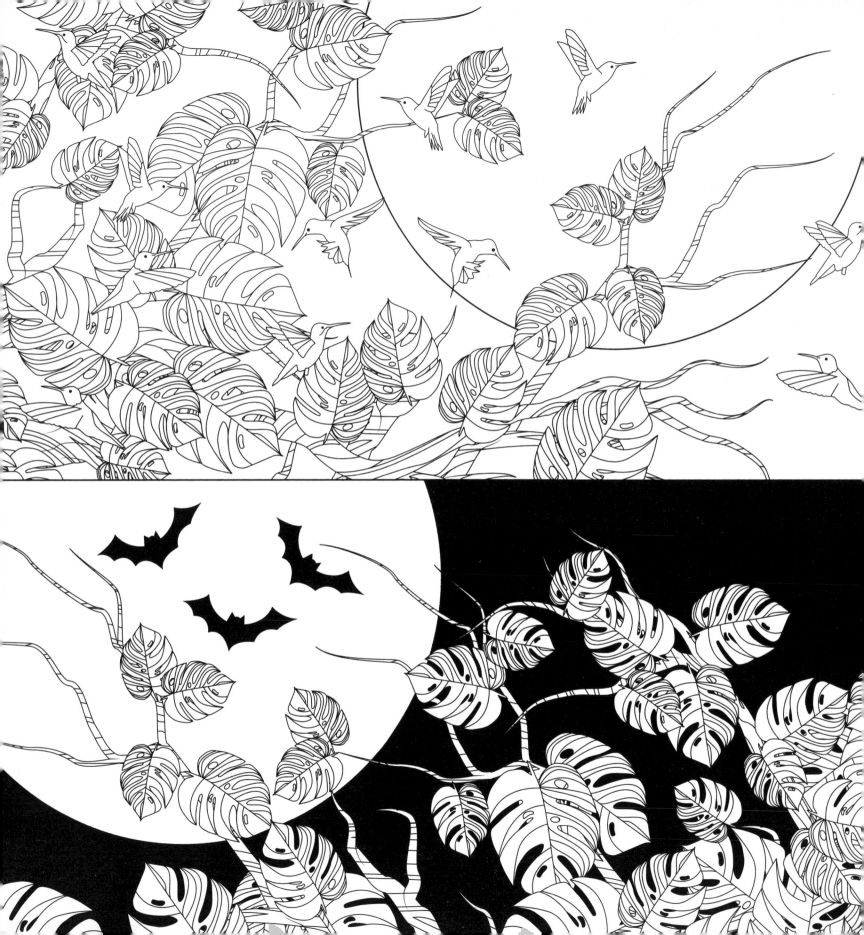